100s visual ideas

Published by Angela Patchell Books Ltd
www.angelapatchellbooks.com

registered address
36 Victoria Road, Dartmouth
Devon, TQ6 9SB

contact sales and editorial
sales@angelapatchellbooks.com or
angie@angelapatchellbooks.com

ISBN: 978 1 906245 04 7

Book design by Matt Woolman / PLAID Studios
www.plaidstudios.com

Book layout and production by Ann Ford
www.chambers-design.com

Book concept by APB

Printed by SNP, China

100s

visual
ideas

LOGOS &
LETTERHEADS

MATT WOOLMAN

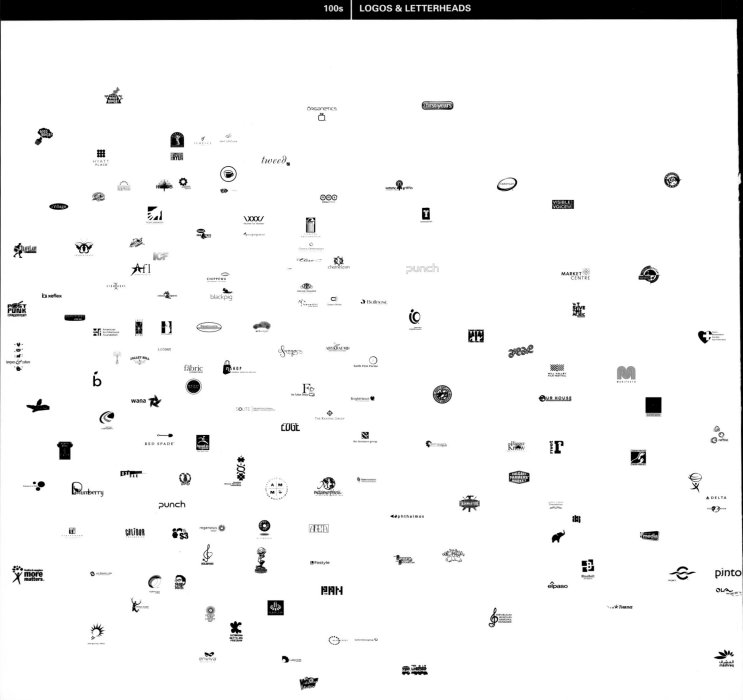

Welcome to the *100s: Visual Ideas* series. This is a collection of source books for stimulating ideas, and developing them into successful solutions. Each title is two books in one: 1) an informational reference, with captions, diagrams, and illustrations that provide practical details that are essential but often hard to find in one place; 2) and a visual reference, featuring literally 100s of successful solutions to stimulate the creative eye and mind. Each book in the series is a compact size, and bound in a durable casing — a perfect reference companion for students and professionals on the go.

This first title features logotypes, stationery systems, and visual identity programs. The logo, more technically known as a trade or service mark, is probably the most concise, portable, and powerful visual communication element that a designer creates. Logos exist in the social sphere, and are thus interpreted and read by audiences of varying sizes. A logo is also known as an identity mark, and provides just that for an organization or individual: a kind of guarantee of quality in the product or service they offer. But logos also have the power to emit connotations beyond identification. Consider the now famous Enron logo. Designed by Paul Rand, the mark originally conveyed strength and innovation in American business. Now, it stands for scandal and corruption in corporate America.

A well-designed logo has a potential lifespan of many years, even generations. The development of a logo is not a simple act of creativity. It involves thorough research and development that starts with the client's goals, and ends with the function of the mark in the public realm.

The informational reference section in this book contains three topics that play a role in logo development. *Gestalt psychology* addresses human perception. Humans naturally engage in pattern-seeking in order to complete or make sense of what they see. *Visual semiotics* explains the different types of images and how humans interpret them. *A morphology of logo design* is a tool for designers to develop a range of possibilities in the formal development of a logo.

The visual reference section in this book is divided into three sections, according to the categories of marks: trade, service, symbol (or experience).

According to the United States Patent and Trademark Office, a *trade* mark is a word, phrase, symbol or design, or a combination of words, phrases, symbols or designs, that identifies and distinguishes the source of the goods of one party from those of others.

A *service* mark is the same as a trademark, except that it identifies and distinguishes the source of a service rather than a product.

A third category of marks, known as a *symbolic,* is usually used to represent an entire line of products from a single company. These marks symbolize the company itself. One example is the internationally known Nike "swoosh." Additionally, marks used by agencies and organizations that produce special short-term events and campaigns can be classified as symbolic. Additional members of this category include logos for communities, museums and other cultural spaces / places, entertainers, and schools. These organizations offer a service but their value is really in the experience they provide to their audience. For this reason, this book has re-titled the third category as *experience* marks.

Also included with this book is a DVD that contains a diverse collection of animated logos, ready to view on both Macintosh and PC platforms.

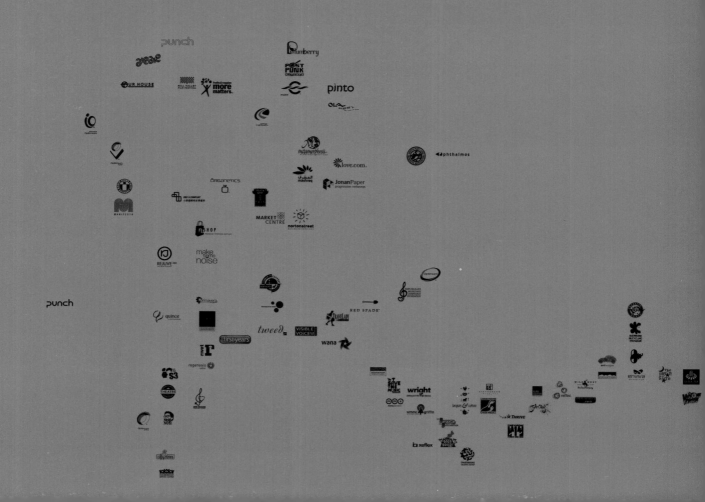

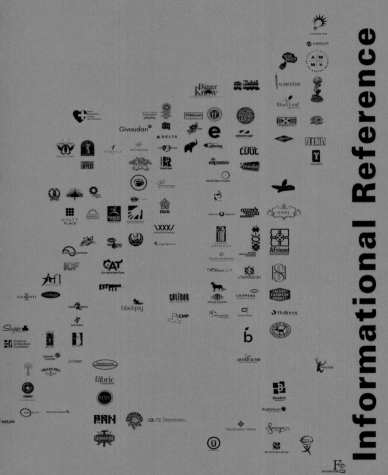

Informational Reference

GESTALT PSYCHOLOGY

VISUAL SEMIOTICS

LOGO MORPHOLOGY

Gestalt Psychology

Founded by Max Wertheimer around 1900, Gestalt Psychology is based on the observation that we often experience things that are not a part of our simple sensations. Gestalt = a unified, meaningful whole. Human behavior naturally engages in pattern-seeking in order to complete or make sense of what they see. The conclusion of this process leads to meaning.

SIX LAWS THAT GOVERN HUMAN PERCEPTION

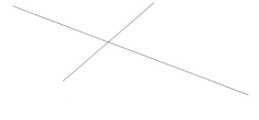

LAW OF PROXIMITY

Elements that are closer together will be perceived as a coherent object.

LAW OF SIMILARITY

Elements that look similar will be perceived as part of the same form.

LAW OF GOOD CONTINUATION

Humans tend to continue contours whenever the elements of the pattern establish an implied direction.

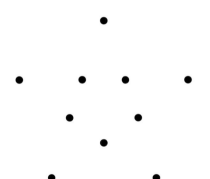

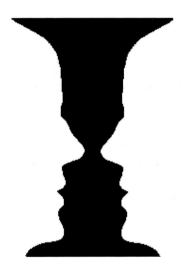

LAW OF CLOSURE

Humans tend to enclose a space by completing a contour and ignoring gaps in the figure.

LAW OF GOOD FORM

A stimulus will be organized into as good a figure as possible. Good = symmetrical, simple, and regular.

LAW OF FIGURE/GROUND

A stimulus will be perceived as separate from its ground.

Visual Semiotics

Swiss linguist Ferdinand de Saussure (1857–1913) is considered the founder of semiotics, which is the study of systems of signs as part of social life. Here, the term "signs" has a wide definition and includes anything that represents something else. Signs can take the form of words, images, objects, sounds, and gestures.

Semiotics is the closest that the discipline of communication design comes to a body of scientific thought about how humans communicate with one another, and the devices we use to accomplish this. Semiotics has a vocabulary that can be used to describe how a sign looks and how it communicates in a specific social context.

SIGN COMPOSITION

Saussure proposed that a sign is composed of two parts: the signifier and the signified. The complete sign is a result of the relationship between these two parts.

A number of linguists and philosophers have since adopted or modified Saussure's original two-part model and established different terms to describe essentially the same parts of a sign. The third part listed below—interpreter—considers the synthesis of all models.

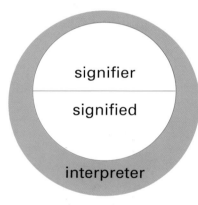

SIGNIFIER
The form that the sign takes, or, what the sign looks like. Another term for this is syntax, which refers to the structural relationships between signs. This is similar to the syntax of written language: the rules that govern the structure and appearance of words, sentences, paragraphs, etc.

SIGNIFIED
The meaning or concept attached to a sign. Another term for this is semantics, or the relationship of a sign to what it stands for.

INTERPRETER
The relation of a sign to an audience reading, or interpreting, a sign. Another term for this is the pragmatics, or function, of a sign. This takes into consideration the frame of reference of the reader, as well as the context of the reader in relation to the sign.

SIGN TYPES

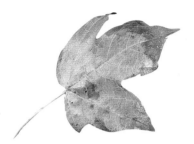

ICON
A sign in which the signifier represents the signified by its likeness. For example, a photograph of a leaf.

INDEX
This type measures meaning by an inherent or causal relationship to an object. An index sign is also known as a pointing sign, as the sign points to something else for its meaning: a tree branch points to a leaf.

SYMBOL
A sign by which meaning is established from an arbitrary relationship between signifier and signified. Meaning is learned through convention, or previous knowledge. For example, the spoken or written form of the word "leaf" represents the object leaf, rather than a bird, or a dog.

METASYMBOL
A symbol that has gained meaning beyond a one-to-one relationship over a period of time and/or a pervasive area of use. Other factors that contribute to the evolution of metasymbols include history, tradition, and culture. Metasymbols can be iconic in their recognizability.

SIGN MEANING

The meanings interpreted in words, images, objects, sounds, and gestures are denotative and connotative:

DENOTATIVE
Interpretation is explicit, self-referential or iconic; the viewer does not necessarily have to work to recognize it.

CONNOTATIVE
Interpretation is implicit and suggests, or implies, a meaning beyond its denotation.

SIGN READING

One reads an image differently from the way in which one reads a word. For example, the word "cat" connotes an image which may or may not be the same as someone else's. With a photo of a cat, however, everyone sees the same cat. The image does not suggest—in this context it denotes, or states.

When we read a book, composed of just text, two types of connotations exist. In the first, we compare the letters within groups to form words. We then compare words in each sentence to form a complete thought. Our grammatical conventions allow us to determine what is the beginning (an uppercase letter) and ending (a punctuation mark) of a complete sentence. The process continues as we compare sentences, paragraphs, and chapters to complete a whole.

At the same time, we are comparing these words and sentences to elements that exist outside of the book itself, in the paradigm. The meaning is not necessarily derived from the words we see, but from a comparison of these words to what we do not see. Our social and cultural persona enters, and we make associations from what we know and understand already—our influences.

Logo Design Morphology

A morphology is the study of the structure and form of a language system, including inflection, derivation, and the formation of compounds. In this book a morphology is presented for the study and development of logo marks.

Morphologies are tools that can be used in the process of creating and analyzing. The beauty of the morphology is its flexibility. It should be considered a source of specific attributes and variables, but also a framework within which to improvise, experiment and invent.

The morphology on the facing page is a morphology for logo design. Presented in a matrix format, this morphology draws upon the thinking of design educators Kenneth Hiebert and Rob Carter. The functioning components of the morphology are its various attributes and variables. The morphology in this book presents attributes — or formal characteristics — in lists under each category, within each of the three categories. For example, 1. MOTIF has one attribute: 1.1 sign. This attribute has several variables: alphabetic, analphabetic, numeric, pictorial, and combination.

Generally, the variables cover a spectrum of possibilities for each attribute. Some describe a range, others are distinct opposites. Hiebert describes this as a contrast continuum. Roland Barthes used the term binary opposition. It is a way of thinking about not only design, but life. For example, considering the human attribute of "feeling," we do not really understand variable of "happy" until we understand "sad." Applied to design, we can consider syntactic (visual) attributes such as a shape varying from geometric (a square) to organic (a tree leaf).

1 MOTIF

1.1	**sign**	alphabetic	analphabetic	numeric	pictorial	combination

2 IMAGE

2.1	**render**	graphic	photographic	drawn	combination
2.2	**shape**	geometric	organic	hybrid	
2.3	**size**	small	medium	large	combination
2.4	**color**	monochromatic	polychromatic	solid	gradient
2.5	**surface**	outlined	shaded	textured	patterned
2.6	**dimensionality**	flat	extruded	shadowed	simulated

3 TEXT

3.1	**face**	old style	transitional serif	modern serif	slab serif	sans serif	hybrid	other
3.2	**case**	upper	lower	combination				
3.3	**size**	small	medium	large	combination			
3.4	**weight**	light	medium	heavy	combination			
3.5	**width**	condensed	medium	wide	combination			
3.6	**posture**	roman	italic	oblique	custom	combination		

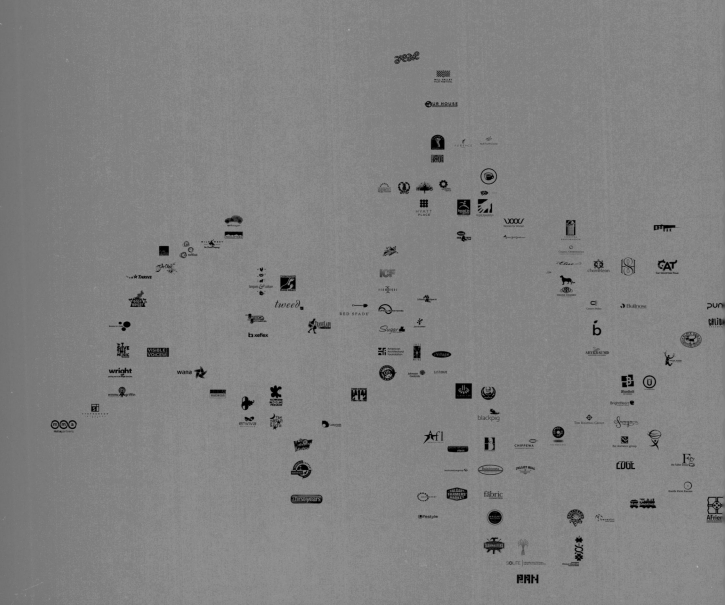

Visual Reference

TRADE MARKS

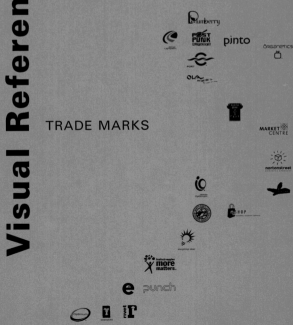

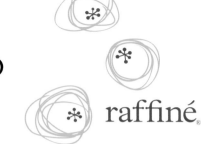

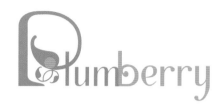

CLIENT: Jacob & Cody Pte. Ltd.

STUDIO: Silnt
DESIGNER: Felix Ng
ILLUSTRATOR: Germaine Chong

CONCEPT: Model and former MTV-VJ Nadya Hutagalung needed an identity for her jewelry line, to represent her as a designer who is classic yet chic.

CLIENT: Raffiné Candy Company

STUDIO: Amy Vainieri
DESIGNER: Amy Vainieri

CONCEPT: The mark for this fictional gourmet candy company began with four key words for the brand: fun, flavor, gourmet and sophisticated. These gave way to patterns of candy, candy shapes and the abstractions of these shapes. The loose strokes offer the impression of delicacy and the playfulness that the brand stands for, while at the same time referencing candy.

CLIENT: Plumberry Fashion

STUDIO: Banan Yaquby
DESIGNER: Banan Yaquby

CONCEPT: Plumberry Fashion is a retail boutique in the Kingdom of Bahrain. The objective was to develop a clean looking logo that targets young females, through the combination of plums and typography.

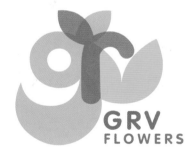

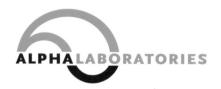

CLIENT: GRV Flowers

STUDIO: Sylvia Vaquer Design
DESIGNER: Sylvia Vaquer

CONCEPT: The letters GRV interact in a floral structure that utilizes a fresh and lively color palette to present this new wholesale flower vendor.

CLIENT: Alpha Laboratories (N.Z.) Ltd.

STUDIO: Visual Voice
DESIGNER: Kayo Takasugi

CONCEPT: Alpha is New Zealand's leading contract manufacturer of dietary supplements and complementary healthcare products. The mark needed to reinforce New Zealand's international reputation for unspoiled natural landscapes and pristine coastal waters, lakes and rivers. A stylized Kiwi – New Zealand's iconic national bird – gives the design a distinct character.

CLIENT: Bewdley Farm Herbs

STUDIO: Another Limited Rebellion (ALR)
DESIGNER: Noah Scalin
ILLUSTRATOR: Noah Scalin

CONCEPT: Bewdley is a small herb farm that distributes to local restaurants. Located on farm that is over a hundred years old, the client wanted to offer a sense of the history associated with their products, which also represents a return to an older way of growing and distributing food.

HIP TO BAMBOO

CLIENT: Hip To Bamboo, LLC

STUDIO: Jing Zhou Studio
DESIGNER: Jing Zhou

CONCEPT: Hip To Bamboo is a company focusing on bamboo fiber clothing and Yoga teaching. The logo design combines "H" in Hip, "B" in Bamboo, and the natural element — bamboo.

ARMANI
JEANS

CLIENT: Armani Jeans

STUDIO: Alexander Isley, Inc.
CREATIVE DIRECTOR: Alexander Isley
DESIGNER: Alexander Isley

CONCEPT: This logo for Armani Jeans, a luxury clothing retailer, uses a classic, typographic approach.

the green glass co.

CLIENT: Green Glass

STUDIO: Another Limited Rebellion (ALR)
DESIGNER: Noah Scalin

CONCEPT: Green Glass is a company that manufactures drinking glasses out of used wine and beer bottles. They wanted to appeal to a hip, young customer base that is interested in environmental issues.

enviva
MATERIALS

CLIENT: Enviva

STUDIO: Another Limited Rebellion (ALR)
DESIGNER: Noah Scalin

CONCEPT: Enviva is an alternative recycling business that transforms tires into feedstock for environmental energy production. The logo is a new take on the typical recycling tropes, using the orange and silver Möbius strip to represent the cycle of use and reuse associated with the products and the inherent energy within.

squarespot
THE ULTIMATE AQUARIUM COMPANY

CLIENT: Squarespot

STUDIO: The Black Pig
DESIGNER: The Black Pig

CONCEPT: Squarespot is an aquarium company with more than 27 years of combined fishkeeping and 14 years of retail experience. They bring a touch of tranquility and beauty to organizations large and small. Their logo expresses this idea with a combination of simple geometric shapes in bright colors.

Hanksville
HOT RODS

CLIENT: Hanksville Hot Rods

STUDIO: BrandSavvy, Inc.
ART DIRECTOR: Karl Peters
DESIGNER: Karl Peters

CONCEPT: Hanksville Hot Rods produces steel products and components for the Hot Rod or racing community. The logo depicts the nature of the business in a very clean manner. The nostalgic typeface and the hood ornament shape attract the new and the old.

CLIENT: Nifty Notes

STUDIO: Fifth Letter
DESIGNER: Elliot Strunk

CONCEPT: This logo for a print-on-demand announcement company uses a simple typeface with thin strokes and a script counterpart that collaborates with the frame abstracting into moving pages. The overall logo presents a synthesis of old and new in communication: handwriting to print and deliver.

CLIENT: MFA Project

STUDIO: Blu Art & Design
DESIGNER: Triesta Hall

CONCEPT: As part of an MFA project, the objective was the brand children's shoes. This particular brand, Cubbies, was designed to be reminiscent of the adventure of parenthood, and the discovery of a new world awaiting the child.

CLIENT: Rumedge Thrift

DESIGNER: Jessica Harllee

CONCEPT: Rumedge is a store in D.C. that sells slightly refurbished, thrifted clothing. The logo emulates the edgy and rough-around-the-edges feel of the store and the clothing itself. It also references the piles of clothing that thrifters often must dig through to come across the perfect find.

CLIENT: Bird in Hand

STUDIO: Hughes design | communications
DESIGNER: Courtney Owens Zieliski, Partner

CONCEPT: Bird in Hand is a line of tote bags. The concept behind the logo is pretty straightforward — a bird in hand! The green represents the fact that these bags are made from a leather alternative.

CLIENT: Rejuve MD

STUDIO: Response Marketing Group
CREATIVE DIRECTOR: Tommy Lee

CONCEPT: An LA-based dermatologist wanted to market a line of anti-aging product line after his success in developing acne products. The identity mark is a combination of the product name spelling (r, j) and function of the product: using growth factor serum to rejuvenate skin cells.

CLIENT: The North Face

STUDIO: Satellite Design
ART DIRECTOR: Amy Gustincic
DESIGNER: Amy Gustincic

CONCEPT: Logo for a series of fast and light clothing and equipment. Both the typeface and the mark signify light, and flight in the angular strokes, curves and angles.

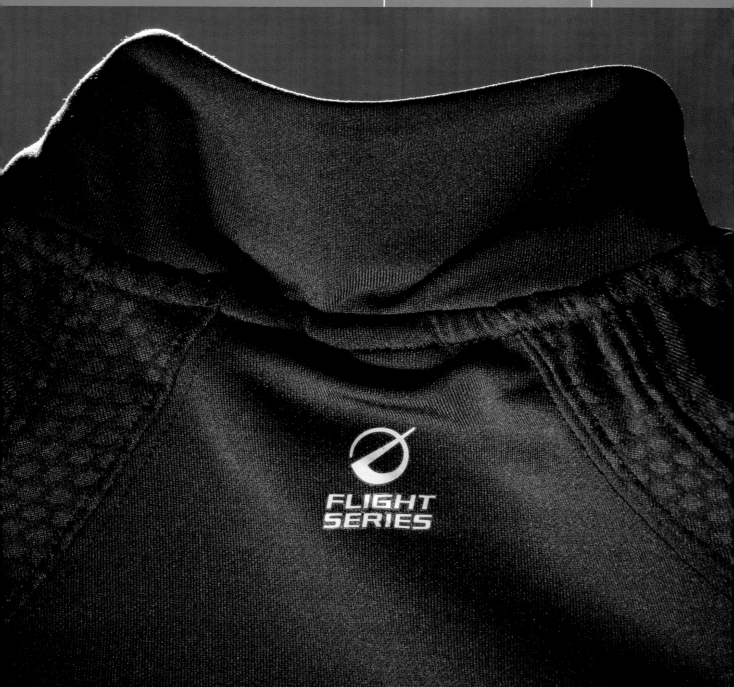

tweed

CLIENT: Tweed

STUDIO: Response Marketing Group
CREATIVE DIRECTOR: Tommy Lee

CONCEPT: Tweed is a chain of young, trendy Southern-themed gift shops in NJ and VA. The objective was to capture a Southern feeling through color and line. A soft, script-style typeface achieves this with a strong color palette that resembles Tiffany, a brand noted as a favorite within the same market.

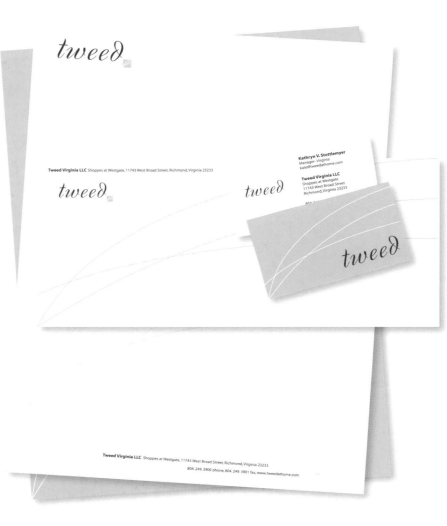

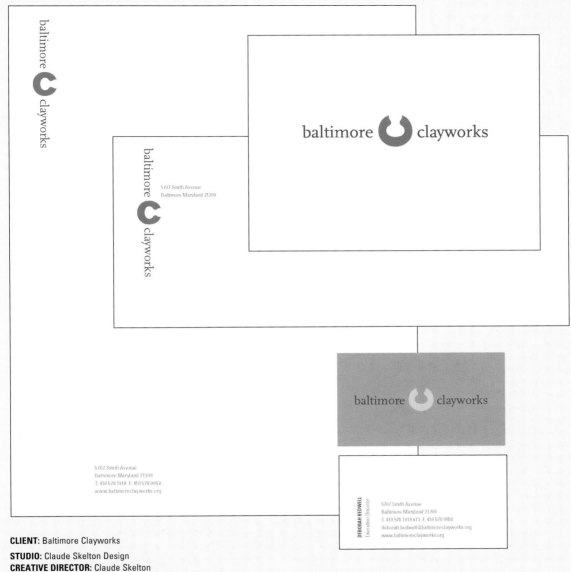

CLIENT: Baltimore Clayworks

STUDIO: Claude Skelton Design
CREATIVE DIRECTOR: Claude Skelton
ART DIRECTOR & DESIGNER: Elizabeth Sprouls
PRINTER: Printing Corporation of America

CONCEPT: Identity design for a ceramic arts organization based in Baltimore, Maryland. The C signifies "Clayworks" and also a clay vessel. The color palette reinforces this with an earthen grey-brown and deep, fiery red.

CLIENT: Alna Pink

STUDIO: vit-e graphic design studio
DESIGN PRINCIPAL: Nathalie Fallaha
DESIGNER: Khalil Halwani

CONCEPT: The challenge was to come up with an umbrella visual identity for a multi-brand fashion store; one limitation was to reflect on the store's interior design. two colors were assigned to Alna Pink's identity, which are pink and black, separately used. The logotype was custom drawn, featuring a new typeface. The rose, an essential element in the interior decoration, was stylized to fit the brand's image.

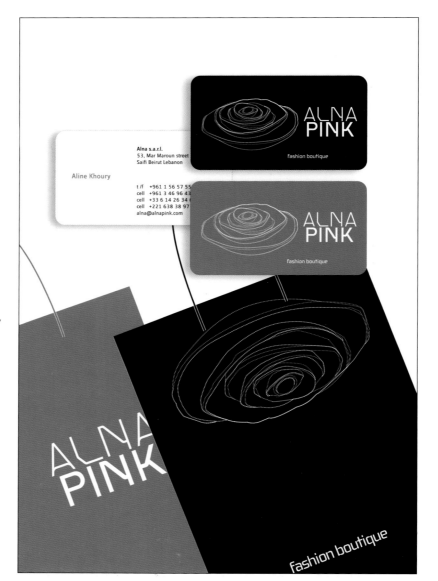

CLIENT: Big Country Ice Cream Company

STUDIO: Arsenal Design, Inc.
DESIGNER: Mark Raebel

CONCEPT: Night time clouds represented by giant scoops of dreamy ice cream delight.

CLIENT: Givaudan

STUDIO: Sterling Brands
DESIGNER: Marcus Hewitt

CONCEPT: The objective was to recharge the global positioning, simplify the name, and design a breathtaking identity system that brings the emotional and experiential nature of this flavors and fragrance brand to life.

CLIENT: Good Pig, Bad Pig

STUDIO: Jeff Fisher LogoMotives
DESIGNER: Jeff Fisher
ILLUSTRATOR: Brett Bigham

CONCEPT: Owner Brett Bigham provided the illustration for his greeting card company identity. Incorporating the pigs and the type treatment created a unique, whimsical identity, similar to the company's greeting card line.

CLIENT: Ooga Booga! Inc.

STUDIO: Fifth Letter
DESIGNER: Elliot Strunk
ILLUSTRATOR: Kim Paillot

CONCEPT: This logo for the board game, Travel Mania, is rendered in a hand-cut style.

CLIENT: *Just Out*

STUDIO: Jeff Fisher LogoMotives
DESIGNER: Jeff Fisher

CONCEPT: The re-design of this news magazine identity gave the publication a fresh, contemporary look. A heavy 1980's typeface was replaced with the slimmer Gill Sans.

CLIENT: Earth First Farms

STUDIO: Richard Zeid Design
DESIGNER: Richard Zeid

CONCEPT: Earth First Farms is an organic apple orchard in Southwest Michigan. The apple was a natural choice for the mark but unlike the "corporate" perfect-looking apple, a more natural, hand-drawn apple was created and paired with a traditional typographic solution.

CLIENT: Run Aesthetic

STUDIO: Run Aesthetic

DESIGNER: Rachele Riley / Run Aesthetic

CONCEPT: *Pinto: Spirit of 'Zine.* This publication investigates a philosophical question in each issue and explores experimental imagery, typography, research and writing. The logotype points to the multi-disciplinary, collaborative and creative spirt of the magazine, one which embraces the unexpected.

CLIENT: Equity Marketing, Inc.

STUDIO: Alexander Isley, Inc.

CREATIVE DIRECTOR: Alexander Isley

DESIGNER: Chuck Robertson

CONCEPT: Equity Marketing is a manufacturer of licensed toys. The 'e' was modified to look like a friendly, smiling face in this simple, yet highly effective identity mark.

CLIENT: Blue Leaf Needlework

STUDIO: Plum Studio

CREATIVE DIRECTOR: Heather Corcoran

DESIGNERS: Heather Corcoran, Stephanie Meier

CONCEPT: The objective of this identity mark is to emphasize the personal, decorative, organic elements of needlework.

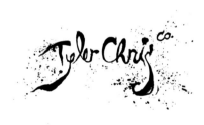

CLIENT: Armstrong Commercial Flooring

STUDIO: Go Welsh

ART DIRECTOR: Craig Welsh

DESIGNER: Ryan Smoker

CONCEPT: Armstrong Commercial Flooring logo for NATURCote, a top-layer finish coat for flooring. Both the uppercase letters and the outlined leaf with a hint of green emphasize the natural element of this product.

CLIENT: Armstrong Commercial Flooring

STUDIO: Go Welsh

ART DIRECTOR: Craig Welsh

DESIGNER: Mike Gilbert

CONCEPT: Armstrong Commercial Flooring "Tileman" logo. A composition of square shapes in different sizes at once signify flooring and a human figure.

CLIENT: Tyler Chris Clothing Co.

STUDIO: Saxony Creative Group

DESIGNER: Michael Peters & Saxony Creatives

CONCEPT: The illustrative style of the logo is fun and deconstructive. Or just messy like a kid!

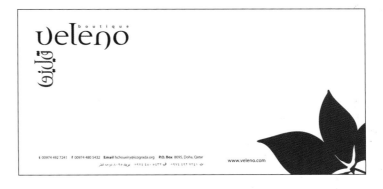

CLIENT: Veleno

STUDIO: Halim Choueiry
DESIGNERS: Halim Choueiry, Sahar Mari

CONCEPT: This logo is inspired by the name Veleno, which means poison in Italian, for this jewelry shop.

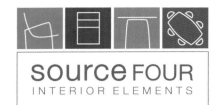

CLIENT: Source Four

STUDIO: The Creative Alliance
CREATIVE DIRECTOR: David Heitman
DIRECTOR OF CREATIVE SERVICES: Jodee Goodwin
CLIENT SERVICES MANAGER: Rachel Volk

CONCEPT: Source Four is a high-end furniture company. The logo design uses iconic symbols to focus on furniture's ability to help people live, work, learn and heal. The entire identity package includes a logo, letterhead and business cards, an interactive product web site, advertisements, and a large envelope.

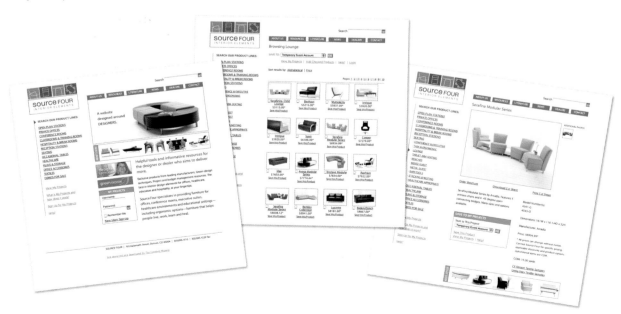

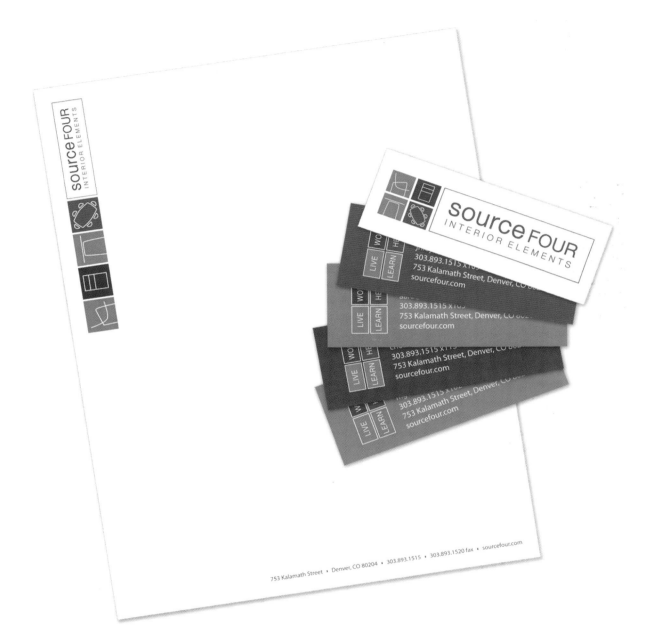

CLIENT: Hakim Mursalin Herbal Products

STUDIO: Muqeem Khan
DESIGNER: Muqeem Khan

CONCEPT: HakimJi is an herbal manufacturing business respected for its owner's fame and goodwill. A pragmatic and strategic thinking was needed to exemplify and utilize the association of already known fame with the new brand identity. A recognized face image and already developed nomenclature of the profession was transformed to a tangible logo mark in order to enhance the business.

CLIENT: 20X200

STUDIO: Little Jacket
DESIGNER: Michael Burton

CONCEPT: 20X200 is a new project from New York gallery owner and curator Jen Bekman. With a mission to make great art affordable, Bekman is featuring work from up and coming artists available in editions of 200, 20 and 2 with prints starting at just 20 dollars.

CLEAROGEN
HORMONAL ACNE TREATMENT

CLIENT: ZO Skin Health

STUDIO: Response Marketing Group
CREATIVE DIRECTOR: Tommy Lee

CONCEPT: Complete Brand Development for Beverly Hills Top Dermatologist, Dr. Zein Obagi, MD's Latest Creation, ZO Skin Health.

Dr. Zein Obagi wanted to make his own line of over-the-counter skin care after his worldwide success from prescription line. Not like other skincare brands, ZO Skin Health carries the weight of this doctor's well-known name. The color palette reinforces this: blue is Dr. Obagi's favorite color; silver is a color of luxury (his clients include the First Lady, The Queen and celebrities); and white is the color of medical/science, referencing Dr. Zein's reputation.

CLIENT: Jaxxwear, Inc.

STUDIO: Kern Design Group
DESIGNER: John Ferris

CONCEPT: Logo for a line of infant wear featuring onesies, shirts, pants and caps. The Jaxxwear name refers to the game of jacks — onesies being a term used in the game. The logo needed to be simple, fun and memorable. The silver color of the jack icon helps to make the identity more unisex.

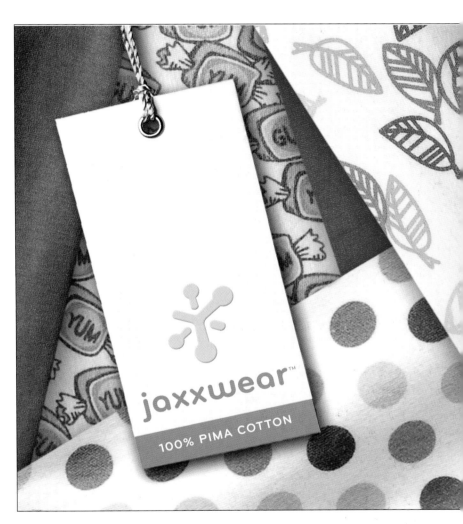

CLIENT: Galva Squared

STUDIO: vit-e graphic design studio
DESIGN PRINCIPAL: Nathalie Fallaha
DESIGNER: Sarine Tchilinguirian

CONCEPT: Kitsch is a boutique and café hosted in a traditional Lebanese house, located in a 1920s Beirut neighborhood. The challenge was to interpret the aesthetics usually associated with the boutique's name, by subverting found images into a mascot, unique to the boutique and café. The visual identity influenced the store planners in their creation of the space in which the customers encounter the brand.

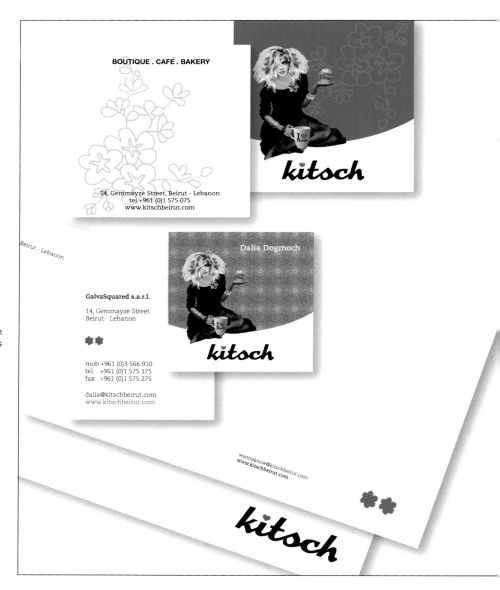

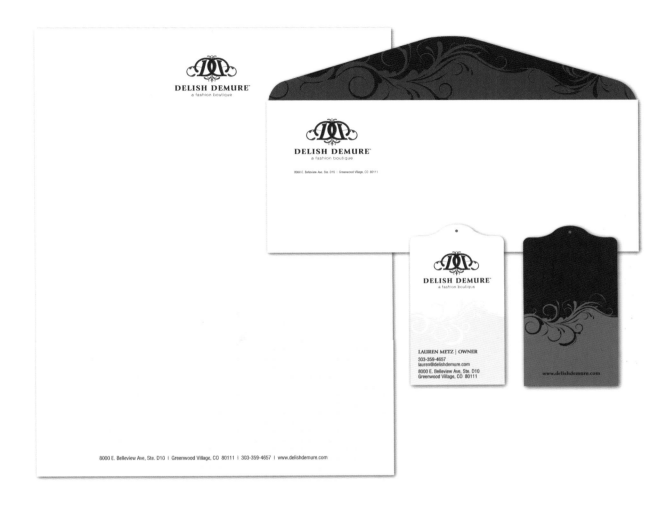

CLIENT: Delish Demure

STUDIO: Cranium Studio
PRINCIPAL/CREATIVE DIRECTOR: Alex Valderrama
DESIGNERS: Andrew Zareck, Nate Valderrama

CONCEPT: Delish Demure is an irresistibly fun women's boutique. The logo design blends classic looking fonts with an eclectic color palette to create a fun element of style.

CLIENT: Buddha Scoots

STUDIO: Doug Fuller, Logo & Identity Designer
CREATIVE DIRECTOR/DESIGNER: Doug Fuller

CONCEPT: Buddha Scoots is the brainchild of an entrepreneur who operates a shop that sells scooters and promotes the scooter lifestyle. He focuses on what he described as the "third eye" in Buddhist teachings and requested a logo that would incorporate this concept in some way. He also wanted the logo to be able to work as a medallion that could be attached to the scooters he sells.

CLIENT: SitOnIt Seating

STUDIO: People Design
CREATIVE DIRECTOR: Yang Kim
DESIGNERS: Michele Brautnick, Alison Popp, Brian Hauch, Sharon Oleniczak

CONCEPT: SitOnIt is a contract furniture company that makes office chairs. In a market that tends to take itself too seriously, they view it as if to say "it's only office furniture" and "it's just a chair — you sit on it!" They play squarely to the middle of the market, emphasizing their bulletproof manufacturing and distribution capabilities over brand flair. The mark plays off this bold, simple idea with an abstract chair form that not only says chair, but suggests a simple flow or process.

CLIENT: Brodeur Pickups

STUDIO: Arsenal Design, Inc.
DESIGNER: Mark Raebel

CONCEPT: This simple but classic design revitalizes a past style to provide the proper identity for a company influenced by guitar manufacturing techniques of the past.

CLIENT: Produce for Better Health

STUDIO: Sterling Brands
DESIGNER: Stephen Dunphy, Brody Boyer, Marcus Hewitt

CONCEPT: This logo signifies a 5-a-day program to increase consumption of fruits and vegetables by leveraging consumer insights.

CLIENT: Anglia Fireplaces

STUDIO: The Black Pig
DESIGNER: The Black Pig

CONCEPT: Anglia Fireplaces is a successful fireplace and surround manufacturer, designer and distributor. Their logo is a typographic solution in a modern face, the letter 'i' also serving as a candle with the dot as its flame. The grey color draws attention to this feature without being obvious.

CLIENT: Hyatt Place

STUDIO: Lippincott
CREATIVE DIRECTOR: Su Mathews
DESIGNER: Su Mathews, Matt Simpson

CONCEPT: Hyatt Corporation's acquisition of Amerisuites provided an opportunity to create a new hotel offering. The Hyatt Place symbol is based on the idea of a "gathering place." The geometric circles come together to form a sense of "place" or locality.

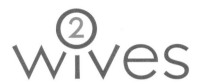

CLIENT: Two Wives

STUDIO: Spin Creative Studio
CREATIVE DIRECTOR: Brigette Schabdach
DESIGNER: Scott Wickberg

CONCEPT: Two Wives Wine Company was created to celebrate the beauty of the balancing act that women perform everyday. Proprietors, Christina and Elizabeth, started the business to bottle some of their favorite varietals and encourage the celebration of the everyday things life offers women.

The previous design of the Two Wives materials supported this concept, but the message was confusing. This new design not only supports their message in a clear way, but it also gives it a very fun and upbeat feel. The unique die cuts were included to represent the strong philosophy behind Two Wives; that all women should feel free to just be themselves and let loose from time-to-time.

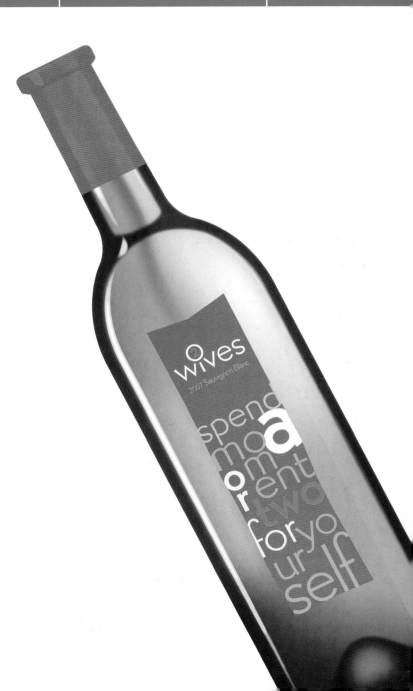

CLIENT: Divergence, Inc.

STUDIO: Plum Studio

CREATIVE DIRECTOR: Heather Corcoran

DESIGNERS: Heather Corcoran, Sarah Lutkenhaus, Evan Dody

CONCEPT: This biotechnology company initiative involves using chemistry informatics to find more effective molecules for the development of new and improved pest control in agriculture. The identity is meant to merge two ideas: molecular innovation and agricultural landscape.

CLIENT: Collectible Creations

STUDIO: Arsenal Design, Inc.

DESIGNER: Mark Raebel

CONCEPT: A feminine palette adds to the attraction of the target audience. The butterfly suggests "creation", while the use of two c's strengthen identity with the company's name.

CLIENT: Alpha Laboratories (N.Z.) Ltd.

STUDIO: Visual Voice

DESIGNER: Kayo Takasugi

CONCEPT: Alpha is New Zealand's leading contract manufacturer of dietary supplements and complementary healthcare products. This sub-brand was designed specifically for a new product line of Vegetable Capsules aimed at the international organic market.

CLIENT: Peter's

STUDIO: Studio SDA

HEAD OF DESIGN: Luke Richards

CONCEPT: Following a management buyout, this major international producer of savory products supplying both retail and food service markets, required a logo and corporate identity that was forward-looking and contemporary while at the same time did not alienate their existing loyal customer base. They therefore needed an identity that was evolutionary rather than revolutionary.

CLIENT: Bakeshop DC

CREATIVE DIRECTOR/DESIGNER: Tommy Lee

CONCEPT: Bakeshop is a unique bakery based in Washington, DC. The proprietor has a "thing" about cupcakes. The logo represens three ideas: chef's hat, abstract look of toast, and of course a cupcake. The deep chocolate and pink colors conjures the appetite for sweet baked goods. The typeface is modern but conveys the idea of birthday cake writing.

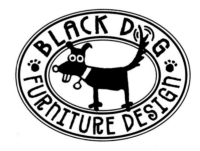

CLIENT: Black Dog Furniture Design

STUDIO: Jeff Fisher LogoMotives

DESIGNER: Jeff Fisher

ILLUSTRATOR: Brett Bigham

CONCEPT: Brett Bigham, the designer of new furniture from recycled parts, had his own drawing of his dog incorporated into the logo for the business. The rough quality of the illustration inspired the use of the selected typeface.

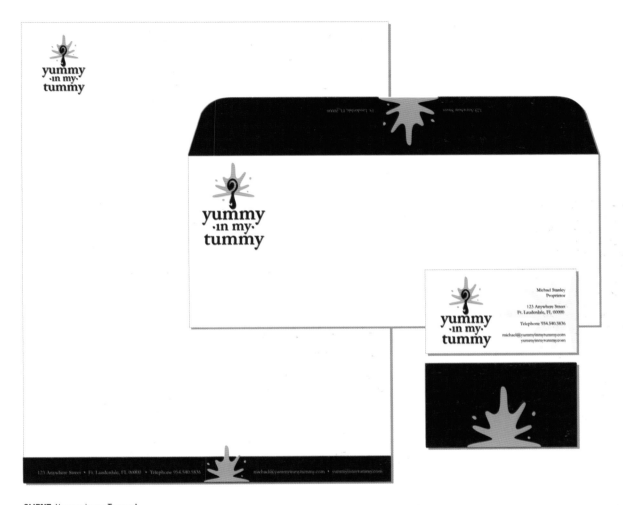

CLIENT: Yummy in my Tummy!

STUDIO: Mazziotti Design
DESIGNER: Jordan Mazziotti

CONCEPT: The logo is rendered in a clean, direct manner. The splash of food from the end of the spoon signifies the immediate satisfaction of tasty food.

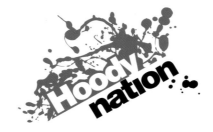

CLIENT: Spout

STUDIO: People Design
CREATIVE DIRECTORS: Yang Kim, Kevin Budelmann
DESIGN DIRECTOR: Michele Brautnick
ILLUSTRATOR: Henk Dawson

CONCEPT: Spout is an online film community. Their goal was to be the source — or spout — for many things related to the film. They also wanted to be a place where people can spout off their opinions about what they love and hate about film. The logo reflects their casual nature, rounded Cooper Black is bold and friendly, and reminicent of 1970s Herman Miller posters at MOMA and custom t-shirts at the mall. The droplet shape of the "O" serves as an amorphous, graphic target — the center of the word. It is 3D, smooth, and reflective — a little bit like Hollywood. It deliberately can be interpreted in many ways, but among them is that it is a droplet from the "spout."

CLIENT: Hoody Nation

STUDIO: Arsenal Design, Inc.
DESIGNER: Mark Raebel

CONCEPT: This website offers the opportunity for individuals to submit designs for hooded sweatshirts. The activeness created by the paint splatters dominates most of this logo in order to capture the viewer, as well as expresses youthfulness and creativity.

CLIENT: Edison Surfboards

STUDIO: Arsenal Design, Inc.
DESIGNER: Mark Raebel

CONCEPT: The stylized "E" creates the nose of the company's number-one product, a surfboard.

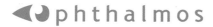

CLIENT: Ophthalmos

STUDIO: The Black Pig
DESIGNER: The Black Pig

CONCEPT: Ophthalmos specialises in the design and manufacture of medical devices for use in ophthalmoscopy. It recently developed the world's first lens free ophthalmoscope, the Optyse™. The device is unique in its simplicity, size and affordability and is set to transform retinal screening in general medical practice across the globe.

CLIENT: Sprinkles Ice Cream

STUDIO: Arsenal Design, Inc.
DESIGNER: Mark Raebel

CONCEPT: Dimensional and delicious in appearance, causing the viewer to crave a cone. A logo for an ice cream shop on the waterfront.

CLIENT: Harriet Kelsall Jewellery Design

STUDIO: The Black Pig
DESIGNER: The Black Pig

CONCEPT: The Black Pig created this typographic solution for a jewelry designer. The objective was to convey handcrafted elegance and refined styling that Kelsall's work embodies.

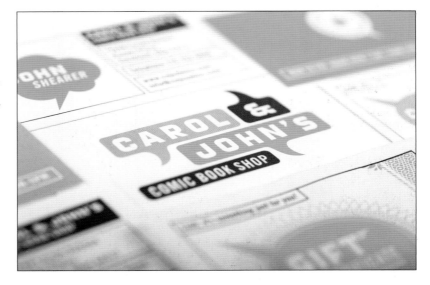

CLIENT: Carol & John's Comic Book Shop

STUDIO: Little Jacket
DESIGNER: Michael Burton

CONCEPT: Carol & John's is more than just a place to find comics. It is an integral part of the local community. John is a local firefighter and his mother, Carol, works at the shop and answers the phone. They wanted a new identity system as they prepared for a move just a few doors down to a bigger and better location.

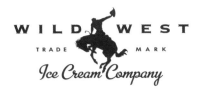

CLIENT: Wild West Ice Cream Company
STUDIO: Arsenal Design, Inc.
DESIGNER: Mark Raebel
CONCEPT: This simple logo pays homage to the old west style for a modern company.

CLIENT: Calidor Creameries
STUDIO: Arsenal Design, Inc.
DESIGNER: Mark Raebel
CONCEPT: Fun, fresh and fruity typography and color.

CLIENT: Atomic
STUDIO: Arsenal Design, Inc.
DESIGNER: Mark Raebel
CONCEPT: Scientific-looking in color scheme, cropping and offset positioning of the letter "a" no doubt creates the nucleus of this logo. The atom is orbiting the character with a stroke of white light creating a sense of movement.

CLIENT: The First Years
STUDIO: Arsenal Design, Inc.
DESIGNER: Mark Raebel
CONCEPT: Refresh of a long-standing power brand that creates baby products: a three-dimensional, gel-like, soft shape.

CLIENT: The First Years — Take & Toss
STUDIO: Arsenal Design, Inc.
DESIGNER: Mark Raebel
CONCEPT: The eye catching combination of bright and contrasting colors reflects the energy and playfulness of the children these products are marketed towards.

CLIENT: Anemone Makeup
STUDIO: Arsenal Design, Inc.
DESIGNER: Mark Raebel
CONCEPT: In this logo for a makeup company, soft circular shapes represent subtle variations in skin tone. Calculated positioning of dots creates a feminine gesture that is again echoed in the rounded characters of the font. The font and mark together, harmonize in perfect balance.

TY TANGLWYST
D A I R Y

CLIENT: TY Tanglwyst Dairy

STUDIO: Studio SDA
HEAD OF DESIGN: Luke Richards

CONCEPT: The TY Tanglwyst Dairy is a family-run dairy farm based in South Wales. The family decided to process and bottle their milk on their farm and supply to the local area. The identity reflects the family's long and distinguished heritage and its place in the local community, while creating a strong and memorable brand to compete in an extremely competitive marketplace.

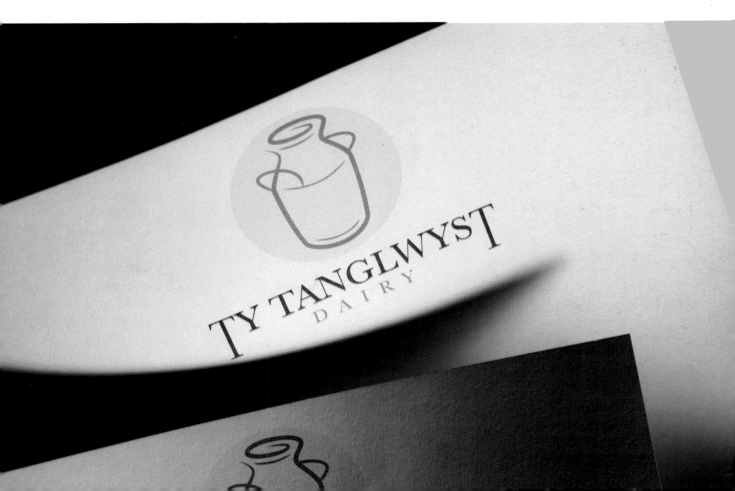

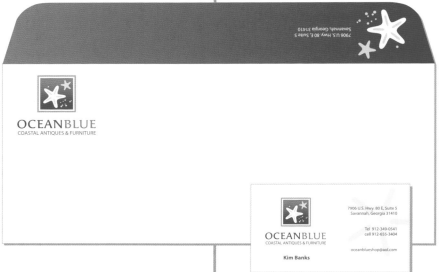

7906 U.S. Hwy. 80 E, Suite 5 · Savannah, Georgia 31410
Tel 912-349-0541 · oceanblueshop@aol.com · www.oceanblueshop.com

CLIENT: Ocean Blue

STUDIO: Mazziotti Design
DESIGNER: Jordon Mazziotti

CONCEPT: Antique store in Georgia.

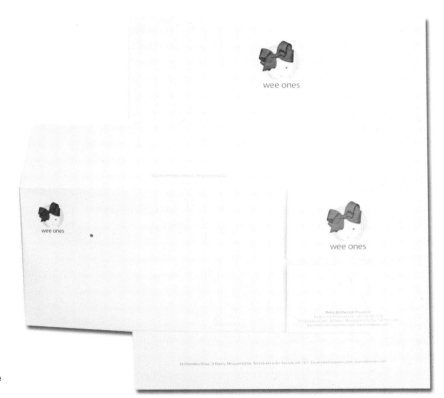

CLIENT: Wee Ones

STUDIO: Spin Creative Studio
CREATIVE DIRECTOR: Brigette Schabdach
DESIGNER: Ruth Waddingham

CONCEPT: Wee Ones is the premier provider of infant and girls' hair accessories in the nation. Since its inception 30 years ago, the company has expanded its offerings to include flip-flops, hats, tote bags, belts, pacifier clips and more. Ten years ago, it added a line designed specifically for Tweens called Deidra and Kiki (www. deidraandkiki.com).

More recently, Wee Ones launched a couture line for its fanciest of clients as well as an organic line for its more earthy ones. Wee Ones desperately needed a make-over for the amount of growth it had achieved. A clean, modern look with bright fun colors. Incorporating the stitching and ribbon in the brochure and buyers guide related the buyer with the product. A new design for the packaging was introduced. The bow on the business card and letterhead is a sculpted die.

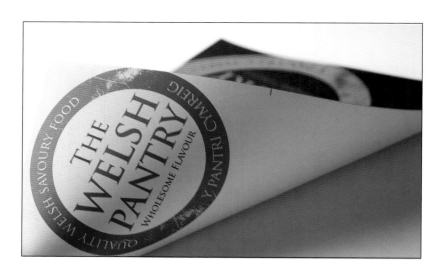

CLIENT: Welsh Pantry

STUDIO: Studio SDA
HEAD OF DESIGN: Luke Richards

CONCEPT: Welsh Pantry is a small producer of savory pastry products. Studio SDA designed the logo in the essence of a quality seal, or stamp, to reflect the heritage of the company and the provenance of the products. The use of the welsh language in the logo also pays homage to their Welsh tradition.

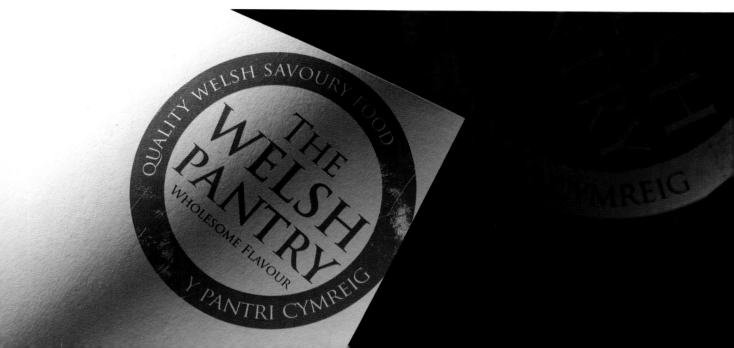

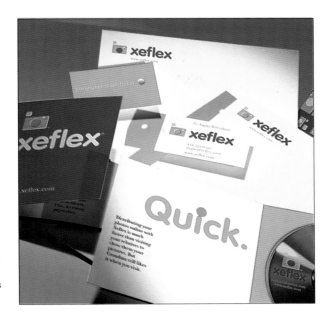

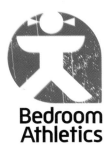

CLIENT: Xeflex Software

STUDIO: Kern Design Group
DESIGNER: John Ferris

CONCEPT: This software company needed an identity and stationery system that communicated the core attributes of their product: simple, quick, fun and private software for sharing digital photos on the web.

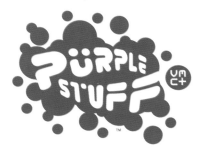

CLIENT: Bedroom Athletics

STUDIO: Studio SDA
HEAD OF DESIGN: Luke Richards

CONCEPT: Aimed predominately at the female market, the girl motif with hair in bunches sets the cheeky tone for this youth culture clothing brand. This is offset against the distressed, weathered background letter 'a' for athletics, which alludes to a surf culture aesthetic.

CLIENT: Purple Stuff

STUDIO: Another Limited Rebellion (ALR)
DESIGNER: Noah Scalin

CONCEPT: Purple Stuff is a fictional product that is part of the science fiction universe: League of Space Pirates, which exists as a comic book & web video series.

CLIENT: J28

STUDIO: Plum Studio
DESIGNER: Heather Corcoran

CONCEPT: This logo for a children's bag/pillow business (customized sewing) emphasizes the textures of fabric and ideas of customization.

CLIENT: Central Michigan Paper (CMP)

STUDIO: People Design
CREATIVE DIRECTOR: Yang Kim
DESIGN DIRECTOR: Michele Brautnick

CONCEPT: This new identity for CMP conveys the wit, brains and speed of a venerable old company that knows its product and customers.

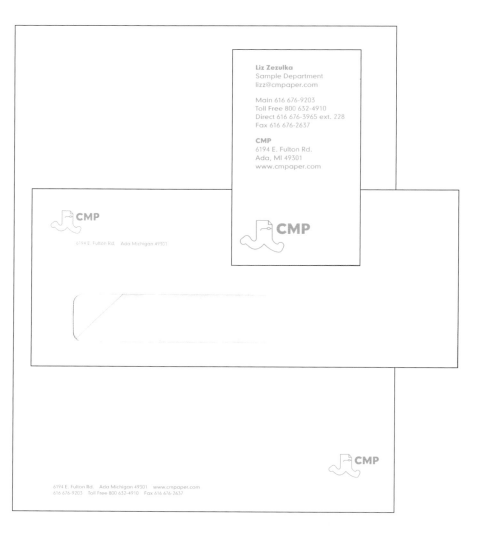

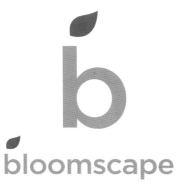

CLIENT: Bloomscape

STUDIO: People Design
CREATIVE DIRECTOR: Yang Kim
DESIGN DIRECTOR: Michele Brautnick
DESIGNER: Tim Calkins

CONCEPT: The organically-shaped "b" logo seems ideal for this start-up company that sells high-end plants. Consumers agree. One even said, "your logo is fantastic. Kiss whoever came up with it."

bloomscape
3525 Bristol Ave NW
Grand Rapids MI 49544
T 616 855 1983
F 616 785 8479
bloomscape.com

Bloomscape Inc. bloomscape.com

Justin Mast President
justinmast@bloomscape.com

Bloomscape Inc.
3525 Bristol Ave NW Grand Rapids MI 49544
T 616 855 1983 F 616 785 8479
bloomscape.com

bloomscape
3525 Bristol Ave NW
Grand Rapids MI 49544

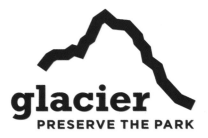

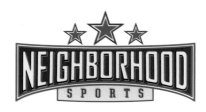

CLIENT: Glacier National Park Fund

STUDIO: Plum Studio
DESIGNER: Heather Corcoran

CONCEPT: This logo for Glacier National Park merchandising abstractly communicates the memorable outline of the mountain. The overall identity is designed to complement Patagonia merchandise.

CLIENT: Wine Garage

STUDIO: Spin Creative Group
CREATIVE DIRECTOR: Brigette Schabdach
DESIGNER: Scott Wickberg

CONCEPT: Wine Garage is a wine store located in Calistoga, California, with over 200 different wines available. Todd Miller, founder and wine buyer, seeks out and personally visits small wineries throughout the state. He often drops by rural, less-traveled vineyards whose wines are not easily accessible to consumers. The shop is housed in a historic fuel station from the 1950s. The retro design of their materials was influenced by the style of this era. Todd's truck is represented in the illustrated logo along with the barrels of wine that he finds during his travels and brings back to his shop.

CLIENT: Neighborhood Sports

STUDIO: Arsenal Design, Inc.
DESIGNER: Mark Raebel

CONCEPT: Evocative of old-time baseball symbolized by pinstripes, stadium shape, vintage patriotic color scheme.

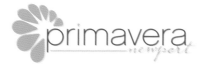

CLIENT: Jolley Hill BBQ

STUDIO: Arsenal Design, Inc.
DESIGNER: Mark Raebel

CONCEPT: Logo for the finest BBQ in Texas. Color usage and star chosen to represent Texas authenticity.

CLIENT: Island Sports

STUDIO: Arsenal Design, Inc.
DESIGNER: Mark Raebel

CONCEPT: Created for the oldest windsurfing shop in the US — the flower and typography are reminiscent of traditional "island" surfing.

CLIENT: Primavera Newport

STUDIO: Arsenal Design, Inc.
DESIGNER: Mark Raebel

CONCEPT: Primavera literally translates as "Spring" in Italian. Pedals of a flower surrounding the elegant typography echo a spring theme.

People Design

Hi, I'm **Kevin Budelmann**, designer and planner and President of People Design. I believe in the collective power of people solving problems for people. I'm best reached at kevin@peopledesign.com

People Design helps people make good experiences for other people. We believe that good design makes better things and makes things better. We work at 648 Monroe Avenue NW, Suite 212, Grand Rapids, Michigan, 49503. Call us at 616 459 4444.

peopledesign.com/kevin

Hello, I'm **Yang Kim**, Creative Director and owner. I make sure our work is impactful and elegant. In other words, I teach our people to push and pull and work hard and play until it's right. Email me at yang@peopledesign.com

People Design helps people make good experiences for other people. We believe that good design makes better things and makes things better. We work at 648 Monroe Avenue NW, Suite 212, Grand Rapids, Michigan, 49503. Call us at 616 459 4444.

peopledesign.com/yang

CLIENT: People Design

STUDIO: People Design
DESIGN DIRECTOR: Yang Kim
DESIGNER: Tim Calkins, Michele Brautnick

CONCEPT: After 10 years in business, BBK Studio renamed themselves People Design. They thought a forward-looking firm would have a name that represented a point of view, not just the initials of the founders. More about that here.

The business materials reflect thei values and design sensibilities — modern but personal, functional but unique, hopefully memorable, human. Contemporary with a nod to history.

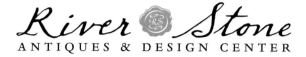

CLIENT: River Stone Antiques & Design Center

STUDIO: Kern Design Group, LLC.
DESIGNER: John Ferris

CONCEPT: River Stone Identity and Stationery:
Kern developed the identity, stationery,
promotional materials and exterior signage for the
River Stone Antiques and Design Center, located
in a historic stone building on the Hudson River.

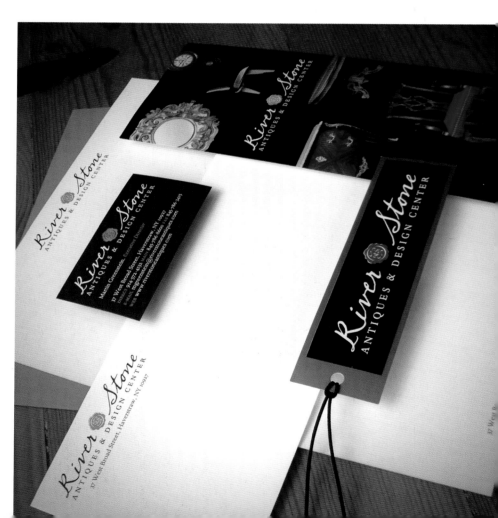

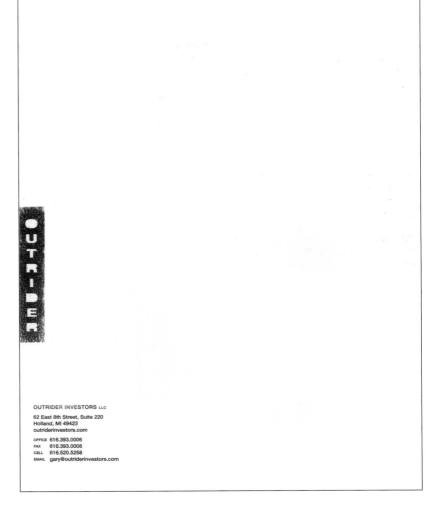

CLIENT: Outrider Investors

STUDIO: People Design
DESIGN DIRECTOR: Brian Hauch
DESIGNER: Tim Calkins

CONCEPT: In addition to designing the identity system, People Design assisted in naming this privately-held bridge loan financing company. Outrider Investors is a pre-venture capital investment company, a trend in investing due to new regulations around VC money. Thus they operate "outside" the system. Additionally, they tend to attract high net worth individuals with "cowboy" -like sensibilities. The image of the "outrider" conveys taking risks, and earning your money. The graphic treatments played off this theme via signage from the old west, blue jeans, and leather boots, belts, reins.

OUTRIDER INVESTORS LLC
62 East 8th Street, Suite 220
Holland, MI 49423
outriderinvestors.com

OFFICE 616.393.0006
FAX 616.393.0008
CELL 616.520.5258
EMAIL gary@outriderinvestors.com

twelve°

PERFORMANCE
HEALTH PRODUCTS

CLIENT: 12 Degrees

STUDIO: Studio SDA

HEAD OF DESIGN: Luke Richards

CONCEPT: Twelve degrees centigrade is considered to be the optimum temperature to drink bottled water in order to fully appreciate its particular qualities and characteristics. This was the rationale behind this name and logo created by Studio SDA for this premium-bottled water brand. The bold classic serif typeface reflects its premium positioning in the market. The degrees symbol, also serves as a lighthearted image of an air bubble in water.

CLIENT: Performance Health Products

STUDIO: Studio SDA

HEAD OF DESIGN: Luke Richards

CONCEPT: Performance Health Products is a company that specializes in the design and manufacture of sophisticated back support systems for people who are confined to a wheelchair due to back injury. They deal directly with the end-user so the logo, which is abstracted from a section of human vertebrae, was softened to project a comfortable feeling. This contrasts with the bold condensed sans serif type face that reflects the serious nature of their business.

CLIENT: Thresher Group

STUDIO: Sterling Brands

CREATIVE DIRECTORS: Marcus Hewitt, Janice Pedley

CONCEPT: Under intense competitive attack from supermarket and convenience store chains and threatened by its own tired and dated retail environment, Threshers, The UK's largest off-license (beer, wine and spirits) retailer, needed to create a more engaging and profitable consumer proposition and retail experience.

Combining aggressive pricing with a compelling consumer benefit, Sterling helped Threshers create a new positioning around the concept of making a good time great. They designed a telegraphic and iconic new identity system that extended from corporate identity into store merchandising and communications, as well as a new retail format called Threshers+Food. In addition, Sterling revamped virtually every one of Threshers private label wines, beers, spirits, and ready-meals, and helped create a totally new wine brand which went on to become one of the UK's top 10 selling wines within a year of launch.

CLIENT: Death & Taxes Magazine

STUDIO: Little Jacket
DESIGNER: Michael Burton

CONCEPT: Magazine redesign and Brand Mark development for New York based magazine.

CLIENT: Organetics

STUDIO: Another Limited Rebellion (ALR)
DESIGNER: Noah Scalin

CONCEPT: Organetics is a fictional product from science fiction universe: League of Space Pirate, which takes the form of a comic book & web video series.

CLIENT: Verde Coffee

STUDIO: Studio SDA
HEAD OF DESIGN: Luke Richards

CONCEPT: Verde imports and distributes coffee beans to the cafe/bar market. 'Verde' is Italian for green — the color of coffee beans when they are harvested. The bold, bright red and orange color palette and rounded sans serif typeface represent the youthful nature of the brand. The letter 'V' is topped with an aromatic "whiff" alluding to the evocative coffee aroma.

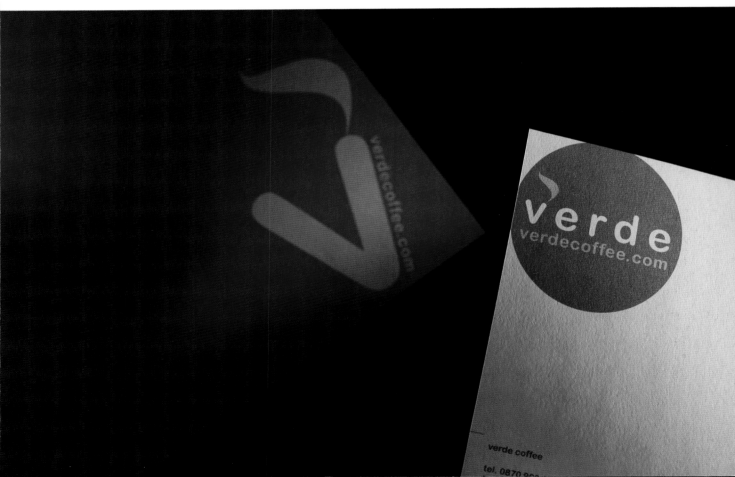

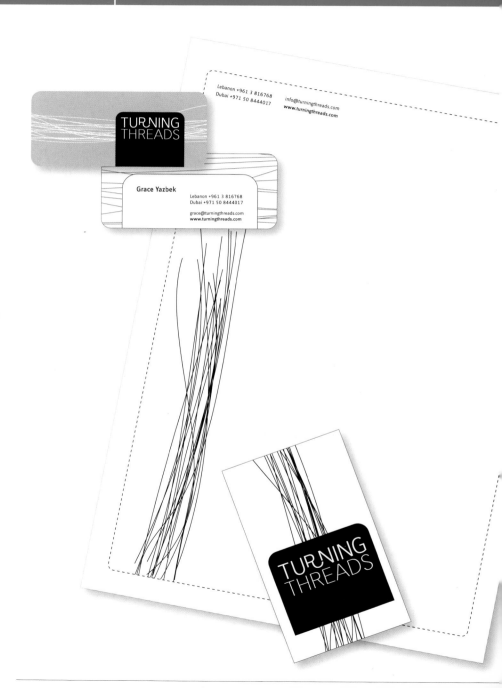

CLIENT: Graze Yazbek

STUDIO: vit-e graphic design studio
DESIGN PRINCIPAL: Nathalie Fallaha
DESIGNER: Khalil Halwani

CONCEPT: The Turning Threads furniture line offers two things: a ready-made collection, which is seasonal, and client specific customization services for those who need something exclusive. This creates a harmony in contradiction, forming a dialogue between styles, materials, colors and textures, serving both function and fashion. The solution is a slick logotype, enclosed in a soft cartouche, with a color palette limited to black and white, keeping the contrast with the furniture items optimal.

CLIENT: Sunya Boutique

STUDIO: Arsenal Design, Inc.
DESIGNER: Mark Raebel

CONCEPT: Logo created for a dress boutique by the sea. Stylized typography is feminine and flowing like a dress in a breeze. The wave under boutique represents the sea.

CLIENT: Flock Tex, Inc.

STUDIO: Arsenal Design, Inc.
DESIGNER: Mark Raebel

CONCEPT: The "f" naturally nests in the scalloped top of the "t" this is also reflected in teardrop shapes of the color spectrum, which illustrate the client's wide product range.

CLIENT: Head in the Game

STUDIO: Arsenal Design, Inc.
DESIGNER: Mark Raebel

CONCEPT: This logo is for a company that provides products dedicated to unlocking the psychological benefits of youth sports.

CLIENT: Ooga Booga!, Inc.

STUDIO: Fifth Letter
ART DIRECTOR: Elliot Strunk
DESIGNER: Jim Paillot
ILLUSTRATOR: Jim Paillot

CONCEPT: Logo for company creating travel-themed toys.

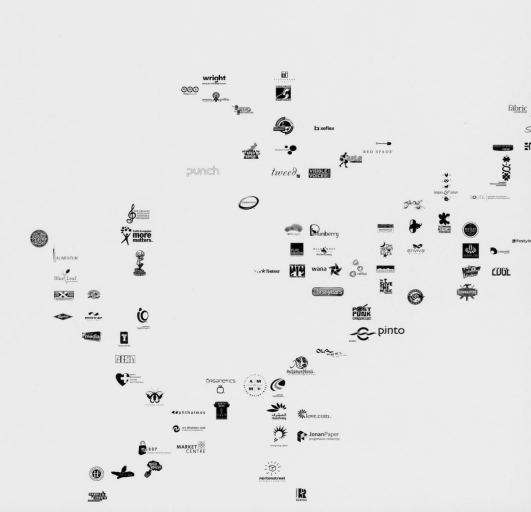

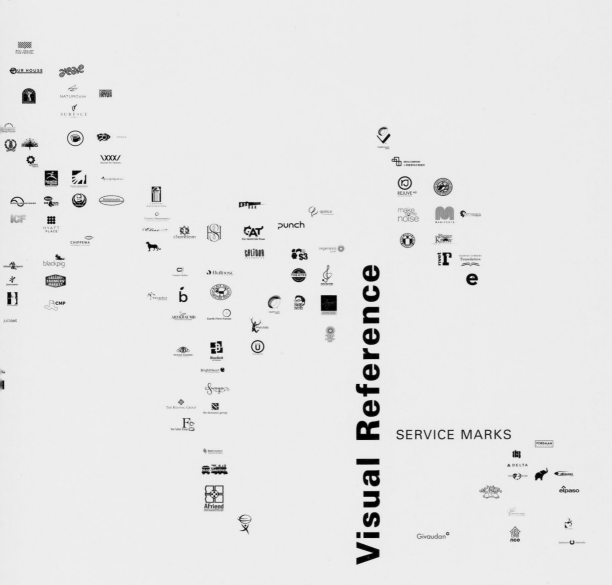

Visual Reference

SERVICE MARKS

CLIENT: The American Architectural Foundation

STUDIO: Sterling Brands
CREATIVE DIRECTORS: Kim Berlin, Marcus Hewitt
DESIGNER: Brody Boyer

CONCEPT: Established in 1943, The American Architectural Foundation is a national nonprofit organization that believes in the power of architecture to improve lives and transform the places where we live, learn, work, and play. Sterling designed a bold, modern identity that not only reads as a graphic monogram reminiscent of a Japanese Hanko stamp, but also echoes an aerial plan view of a city street, complete with pavement, grass and water. The logo functions as the centerpiece of an entire visual system that plays off its elements; an elemental color palette and combination of graphic and organic shapes that form the unique AAF visual language.

CLIENT: Saxony Creative Group

STUDIO: Saxony Creative Group
DESIGNER: Michael Peters & Saxony Creatives

CONCEPT: The use and alteration of several typefaces creates an interesting type composition. The circular nodes connected by long strokes represent the creative network Saxony utilizes to produce their work.

CLIENT: Troy Zimmerman Interior Design

STUDIO: Sarah Giegel Visual Communications
CREATIVE DIRECTOR: Sarah Giegel
DESIGNER: Sarah Giegel

CONCEPT: Representing a "New Generation" of Palm Springs interior design, Troy Zimmerman Interior Design is funky and eclectic. The logo is very versatile with a grid-based system and blocky shapes that depict the modern style reputation of Palm Springs.

CLIENT: SCA Tissue North America

STUDIO: Panarama Design
DESIGNER: Lauri Baram

CONCEPT: THRIVE is a web-based program for talent management. It consists of five components in a progression that depict helping people, managing people, and developing them to succeed. The stars are symbolic representations of success and they are shown to be moving upward and forward.

CLIENT: Snap! Photography

STUDIO: Saxony Creative Group
DESIGNER: Michael Peters & Saxony Creatives

CONCEPT: Snap! Photography is a wedding and event photography company based in Rhode Island. The two women depict the owners of the company. The flourishes and enlarged lowercase letterforms are playful and reflect the journalistic freeform quality of their photography.

CLIENT: Dr. Ary Krau

STUDIO: Panarama Design
DESIGNER: Lauri Baram

CONCEPT: Dr. Ary Krau is a plastic surgeon in the highly competitive Miami/Coral Gables market — there are 96 surgeons within 10 miles; 421 within 25 miles. A plastic surgeon is really in the beauty business: transforming his clients from ugly ducklings to swans. This logo abstracts a swan figure of gestural lines from the K in Krau.

 ONO & COMPANY
小野国際特許事務所

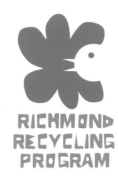

CLIENT: Ono & Company
STUDIO: Visual Voice
DESIGNER: Kayo Takasugi

CONCEPT: Ono & Company is an intellectual property agency providing various services both inside and outside of Japan. The mark is derived from the company's name. A simple two-color composition reveals the mathematical symbol for infinity, alluding to their unending service capabilities worldwide.

CLIENT: The Wright Real Estate Company
STUDIO: Thinkhaus
ART DIRECTOR: Matthew Strange
DESIGNER: John O'Neill

CONCEPT: The goal for the naming of the real estate company, and its identity, was to portray old country values and services. In doing so, Thinkhaus started the design process by listening to Jacob Wright, owner of the company, talking about his rural upbringing in Western Virginia. Thinkhaus became inspired by the use of language and visual characteristics seen in old fashioned food product labels, and old country music letterpress posters. This led to a name for the company and a style that contained the personal touch that Jacob was seeking for the brand.

CLIENT: City Of Richmond
STUDIO: Zoo Valdes
DESIGNER: Marius Valdes
ILLUSTRATION: Marius Valdes

CONCEPT: Birds are one of nature's greatest recyclers. This identity was created to develop a new identity for the Richmond, Virginia Recycling Program that would be fun and friendly for families and children to help encourage the act of recycling. The logotype was developed based on shapes inspired from eggs and bird feet.

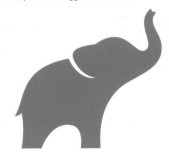

CLIENT: Friends of the Environment – Qatar
STUDIO: Halim Choueiry
DESIGNERS: Halim Choueiry and Aida Hashim

CONCEPT: *Flower Each Spring 06.* Choueiry developed a special typeface based on the Qataf — an indigenous plant to Qatar — to configure into a variety of organic compositions, all serving as the logo for this organization.

CLIENT: Alps Fund Services
STUDIO: BrandSavvy, Inc.
ART DIRECTOR: Karl Peters
DESIGNER: Karl Peters

CONCEPT: The objective was to develop a new identity and design system to help with a more consorted marketing effort. The identity was coined the "Cross Roads," illustrating their multiple services woven into the fiber and fabric of their clients' future.

CLIENT: Digineg
STUDIO: WAX
DESIGN DIRECTOR: Monique Gamache
DESIGNER: Scott Shymko
ILLUSTRATOR: Lotta Bruhn

CONCEPT: Digineg is a service dedicated to preserving digital images and documents onto archival grade film. Once on film, the image or document can last up to 1500 years. The choice of the elephant and the color blue for the logo directly reference beliefs associated with long-term memory.

Making life better *for* children with cancer

CLIENT: ASK

STUDIO: Response Marketing Group
CREATIVE DIRECTOR: Tommy Lee

CONCEPT: ASK is a non-profit organization for
children with cancer. As the organization matured,
they developed a need for a professional branding
package along an update of their iconographic
hand logo.

Lee used childrens toy blocks for the company
name, and placed a block with the hand logo on
the right, slightly higher than others to conveying
the raising of one's hand to volunteer to help.

Anne M. Cuomo
Executive Director
P.O. Box 17184
Richmond, Virginia 23226

804 828 1531
804 683 8177
804 794 0320
acuomo@askweb.org
www.askweb.org

Making life better *for* children with cancer

Assistance.
Support.
Kindness.

Making life better *for* children with cancer

P.O. Box 17184
Richmond, Virginia 23226

Assistance.
Support.
Kindness.

Assistance.
Support.
Kindness.

P.O. Box 17184, Richmond, Virginia 23226 804 828 1531 804 794 0320 www.askweb.org

CLIENT: Friends of the Environment – Qatar

STUDIO: Halim Choueiry
DESIGNERS: Halim Choueiry, Aida Hashem

CONCEPT: Choueiry developed a special typeface and illustration based on the Aaqool — an indigenous plant to Qatar — and incorporated this organic logo into the organization's stationery system and collateral materials.

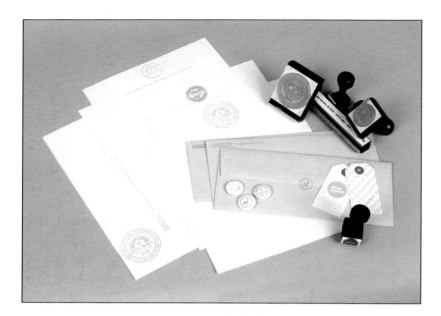

CLIENT: Little Jacket

STUDIO: Little Jacket
DESIGNER: Little Jacket

CONCEPT: Stationery on a budget. Cost effective stamps were used for all elements of Little Jacket's stationery and to express their handmade design aesthetic.

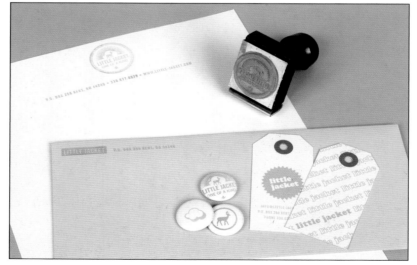

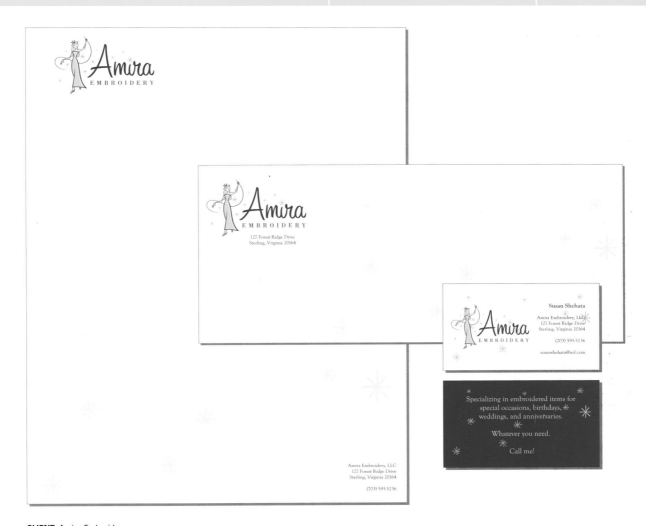

CLIENT: Amira Embroidery

STUDIO: Mazziotti Design
DESIGNER: Jordon Mazziotti

CONCEPT: Amira is a special occasion embroidery
company. The mark conjures imagery associated
with sewing pattern kits, and prom queens.

energizing ideas

CLIENT: Technically Speaking, LLC

STUDIO: Robert W. Taylor Design, Inc.
ART DIRECTOR: Robert W. Taylor
DESIGNER: Robert W. Taylor

CONCEPT: Instead of being involved in the presentation of technical information, the real objective of this one-person business is to motivate engineering students and professionals through keynote speaking, providing ideas to corporate boards based on experience and also to write and be published. The lightbulb represents "idea" and the sun burst rays represent energy in terms of both science and the energetic personality of the principal of the business. Even the angle of the logo adds to its energy.

CLIENT: Wake Forest University

STUDIO: Fifth Letter
DESIGNER: Elliot Strunk
ILLUSTRATOR: Elliot Strunk

CONCEPT: This logo commemorates the 50th anniversary of the relocation of the Wake Forest University campus to Winston-Salem, North Carolina.

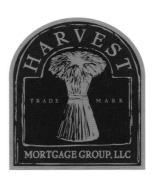

CLIENT: Harvest Mortgage Group, LLC

STUDIO: Arsenal Design, Inc.
DESIGNER: Mark Raebel

CONCEPT: Harvest Mortgage Group is a start-up company with the goal to appear well-grounded and established in the industry. An old fashioned woodcut style was used to symbolize heritage.

CLIENT: Enviro • Air

STUDIO: Fifth Letter
DESIGNER: Elliot Strunk

CONCEPT: Logo for video-guided duct cleaning service. The intertwined, spinning arrows convey two-way directional access, flow, and cleaning.

CLIENT: Appletree Productions

STUDIO: jamidesign
DESIGNER: Jamie Anderson

CONCEPT: Appletree Productions is a woman-centric and organic label so Anderson conveyed that through the image of the tree, lending strength to the female form and keeping it rooted.

COASTAL
RESTORATION

CLIENT: Coastal Restoration

STUDIO: Arsenal Design, Inc.
DESIGNER: Mark Raebel

CONCEPT: Typefaces, colors and symbols used in this logo suggest the "quality of craftsmanship" required to win contracts for home restoration projects.

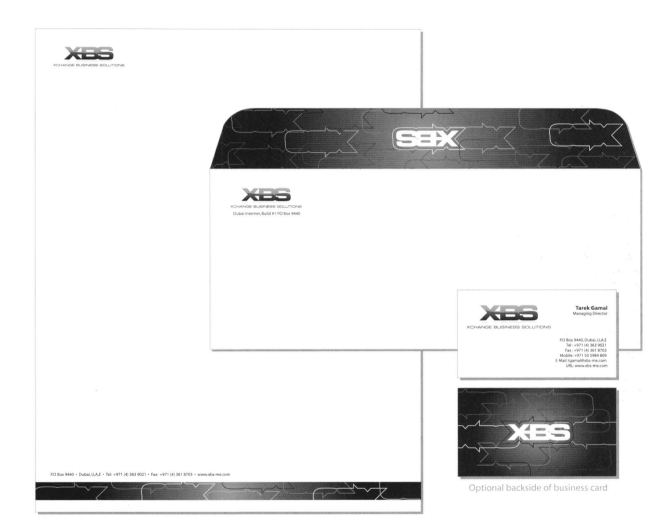

Optional backside of business card

CLIENT: XChange Business Solutions

STUDIO: Mazziotti Design
DESIGNER: Jordon Mazziotti

CONCEPT: Cutting edge design for an IT company based in Dubai. The outlined typographic treatment of the company name set within a red gradient field conveys rich activity in the fast-paced, constantly changing technology industry.

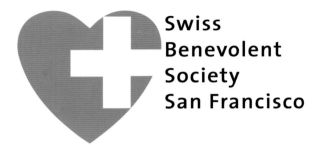

Swiss
Benevolent
Society
San Francisco

CLIENT: Swiss Benevolent Society (SBS)

STUDIO: Studio A N D
CREATIVE CONSULTANT: August Stortz
ART DIRECTOR: Jean-Benoit Levy
DESIGNER: Jean-Benoit Levy

CONCEPT: This organization was founded in 1886 in the USA to support sick, elderly and lonely individuals of Swiss descent. Incorporated in California in 1901, the SBS got its final name in 1976. Their logo needed a redesign with the elements: swiss cross combined with a heart, and a two-color palette: black and red.

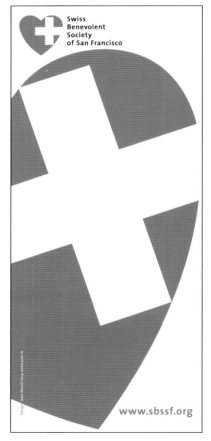

CLIENT: Hoffberger Moving Services

STUDIO: Ayers | Saint | Gross
ART DIRECTOR: Lindsay Story
DESIGNER: Carey McCrone

CONCEPT: ASG was charged with developing an identity for a brand new moving company in the Baltimore, Maryland area. A truck tire tread mark set within a square provided the primary signifier paired with a typographic treatment of the company name. The scope of this project includes logo, stationery, t-shirts, signage, truck design and box design.

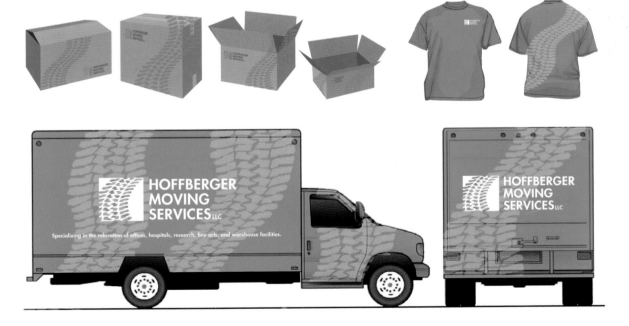

CLIENT: Charles Cormany Photography

STUDIO: Satellite Design
ART DIRECTOR: Amy Gustincic
DESIGNER: Amy Gustincic
PHOTOGRAPHER: Charles Cormany

CONCEPT: Logo and stationery for a photographer who works both traditionally and digitally.

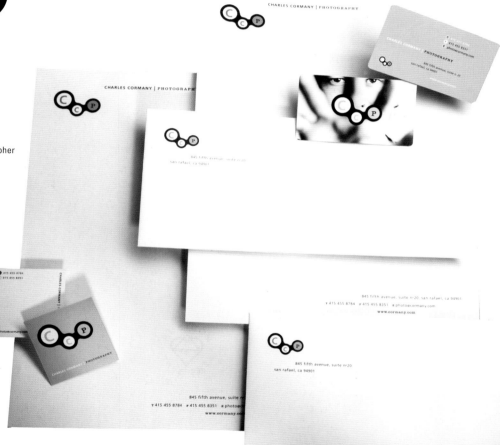

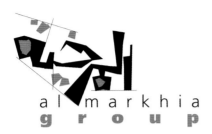

CLIENT: Al Markhia Group

STUDIO: Halim Choueiry
DESIGNER: Halim Choueiry and Aida Hashim

CONCEPT: Developed using angular geometric shapes inspired by the geometry of an aerial view of neighborhoods. Imbedded in the shapes is a map of the I Markhia neighborhood in Doha, Qatar. The red shapes represent the company's activities. The lines represent the extension and interaction, and planning and management of the mother company.

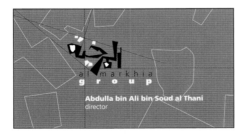

BlueBolt
NETWORKS

CLIENT: Market Centre

STUDIO: BrandSavvy, Inc.
ART DIRECTOR: Karl Peters
DESIGNER: Karl Peters

CONCEPT: Market Centre is a subsidiary of Unified Grocers, a membership organization consisting of grocery store owners. Market Center provides many products and services to its members, depicted by the many squares in the logo. They also provide marketing help to members and help with plan-o-grams and shelf stocking, also depicted by the aerial shot of a store or abstract shot of a shelf full of product.

CLIENT: BlueBolt Networks

STUDIO: Alexander Isley, Inc.
CREATIVE DIRECTOR: Alexander Isley
MANAGING DIRECTOR: Aline Hilford
DESIGNER: Liesl Kaplan

CONCEPT: Logo for an architectural materials specifications company. A slab serif upper-case B reverses out, yet visually fastens the four blue/ black squares in a configuration that resembles a window, rooms, floorplan, of a building.

CLIENT: Communicare CMA

STUDIO: Visual Voice
DESIGNER: Kayo Takasugi

CONCEPT: Communicare is a non-profit, multicultural organization that provides caring support and companionship for people in the community who may be elderly, lonely, disabled or housebound. Themes central to Communicare's mission are suggested through the act of holding hands, signified by the photo image pasted into the typeface. Companion strokes of the neighboring Ms join to form a human figure. Color reinforces the critical aspect of care.

M A N I F E S T O

CLIENT: Urban Chic

STUDIO: Vidale-Gloesener
CREATIVE DIRECTOR: Silvano Vidale
DESIGNERS: Tom Gloesener

CONCEPT: Logo design for a hairdresser in the city center of Luxembourg. The name was given by the client and the solution was the comb and the city skyline emerging as a silhouette within the comb's teeth.

CLIENT: Manifesto

STUDIO: WAX
DESIGN DIRECTOR: Monique Gamache
DESIGNER: Scott Shymko

CONCEPT: Manifesto is a hair salon run by seven independent stylists with an eye toward creating a relaxed, collaborative environment with an Asian esthetic. The lines in the logo represent the founding members while visually referencing hair and Buddhism.

CLIENT: Alamo Mac & PC

STUDIO: Mazziotti Design
DESIGNER: Jordon Mazziotti

CONCEPT: Alamo Mac & PC did not want a logo like all the other computer repair companies, which usually leans either toward technical imagery, or "computer nerd" personality. The client wanted a hip and modern look, with an anti-techie, more down and dirty, not-afraid-to-role-up-their-sleeves-and-solve-the-problem ethic.

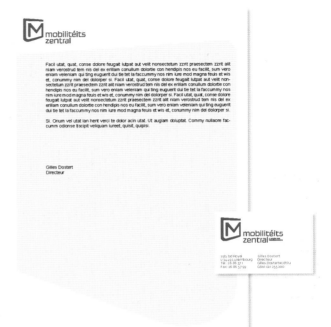

CLIENT: Grand Duchy of Luxembourg

STUDIO: Vidale-Gloesener
CREATIVE DIRECTOR: Tom Gloesener
DESIGNERS: Silvano Vidale, Nicole Goetz

CONCEPT: Logo and corporate design for the public transport authority of the Grand Duchy of Luxembourg. The idea was to create a simple but strong icon that would be applied to all public transportation-related material.

CLIENT: SUD

STUDIO: Vidale-Gloesener
CREATIVE DIRECTOR: Silvano Vidale
DESIGNER: Tom Gloesener

CONCEPT: Logo design for the tourist authority of the south of Luxembourg.

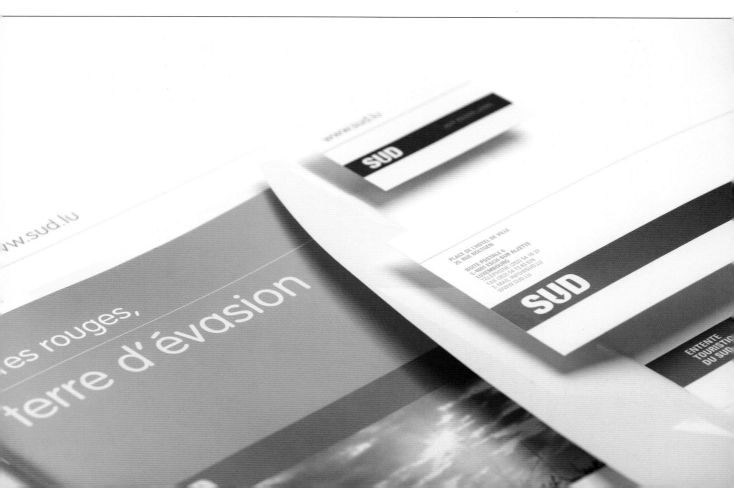

GOOD SAMARITAN
F O U N D A T I O N

CLIENT: Wana (formerly Maroc Connect)

STUDIO: Lippincott

CREATIVE DIRECTOR: Brendán Murphy

DESIGNER: Brendán Murphy

STRATEGY: Denis Bonan, Rune Gustafson, Kat Walker

CONCEPT: Wana is Morocco's new full-service global telecom company offering fixed line, mobile and Internet services. The primary brand color, bright green, communicates a fresh approach, a new idea that clearly differentiates from its competition. The Wana symbol, a dynamic star, references the Moroccan flag and connects with the Moroccan spirit.

CLIENT: Good Samaritan Foundation (GSF)

DESIGNER: Justin K. Howard

CONCEPT: The Good Samaritan Foundation prepares youth for leadership in the community and workplace by student outreach and training. The concept was to embrace and visually translate the GSF mission. The solution incorporates the idea of lending a helping hand and abstractly portrays the many paths to a hopeful future.

CLIENT: Coastal Orthopaedics

STUDIO: Saxony Creative Group

DESIGNER: Michael Peters

CONCEPT: Coast Orthopaedics is a Southern California-based group of doctors who practice non-invasive and orthopedic surgery. This lettermark consists of the C and O creating a joint reflective of the type of work the doctors do.

ROMAN

CLIENT: Sugar Public Relations

STUDIO: Hughes design | communications

DESIGNER: Courtney Owens Zieliski, Partner

CONCEPT: The owner wanted to convey a 1950s housewife style, so a blue/green color with a 50s style typeface and a stylized sugarcube illustration was used to achieve the look.

CLIENT: Regenesis Power

STUDIO: Hughes design | communications

DESIGNER: Courtney Owens Zieliski, Partner

CONCEPT: Regenesis Power offers commercial solar power solutions. This logo was developed using a common symbol for electrical power and a sunny yellow and grassy green to represent generating clean, green power using the sun's rays.

CLIENT: Roman Therapy

STUDIO: Gouthier Design: a brand collective

DESIGNERS: Gouthier Design Creative Team

CONCEPT: Roman Therapy is a high-end holistic massage treatment team that works within boutique hotels. The logo is based on the "rocks" found within the baths of Ancient Rome.

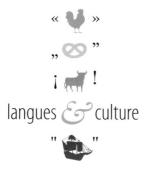

CLIENT: Langues et Cultures

STUDIO: Vidale-Gloesener
CREATIVE DIRECTOR: Tom Gloesener
DESIGNER: Silvano Vidale

CONCEPT: The language teachers' association at the Centre de langues founded Langues et Cultures to promote language and culture. As the volume of their communications grew — including membership cards, posters, invitations, etc. — they needed a new logo. The solution was to use iconic symbols from several different cultures with the words 'langues & culture', highlighting the ampersand.

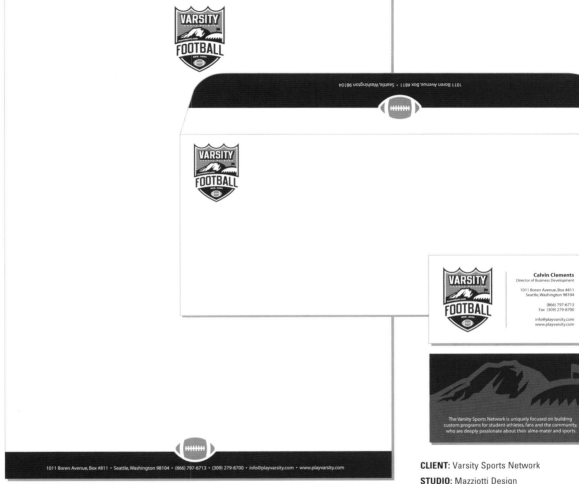

CLIENT: Varsity Sports Network

STUDIO: Mazziotti Design
DESIGNER: Jordon Mazziotti

CONCEPT: Logo and stationery for a company that helps develop custom programs for student athletes. A university-style typeface provides the banner within a shield that contains iconic imagery of a specific sport, the mountainous context of this organization, and a domed stadium where its programs take place.

CLIENT: The Fulton Group

STUDIO: Arsenal Design, Inc.
DESIGNER: Mark Raebel

CONCEPT: Interesting use a ovals creates the dimensional lowercase "g".

CLIENT: Strada Creative

STUDIO: Arsenal Design, Inc.
DESIGNER: Mark Raebel

CONCEPT: Simple and elegant. The horizontal stroke in the letter "A" is replaced by the stem of a flower.

CLIENT: Thomas Fallon — Architect

STUDIO: Jeff Fisher LogoMotives
DESIGNER: Jeff Fisher

CONCEPT: A typeface of the period was used for the identity of this architect specializing in Arts & Crafts inspired design. The 't' in the center icon was created by flipping the 'f' letterform of the type to produce a totally unique ligature and symbol to represent the architect's name.

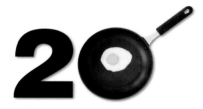

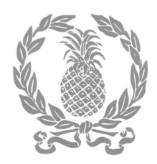

CLIENT: Partnership for a Drug-Free America

STUDIO: Kern Design Group, LLC.
DESIGNER: John Ferris

CONCEPT: This logo commemorates the 20th Anniversary of the Partnership for a Drug-Free America. The mark references the Partnership's pioneering "fried egg" ad: *This is your brain. This is drugs. This is your brain on drugs.*

CLIENT: The Dorrance Group

STUDIO: Arsenal Design, Inc.
DESIGNER: Mark Raebel

CONCEPT: Monogram blending the characters "dg" creating a positive / negative space.

CLIENT: The Thomas Smith Co. LLC

STUDIO: Arsenal Design, Inc.
DESIGNER: Mark Raebel

CONCEPT: Logo created for a company that hosts corporate events. The stylized pineapple was chosen as a traditional symbol of hospitality, a prestigious gift from far away lands.

mmapartners

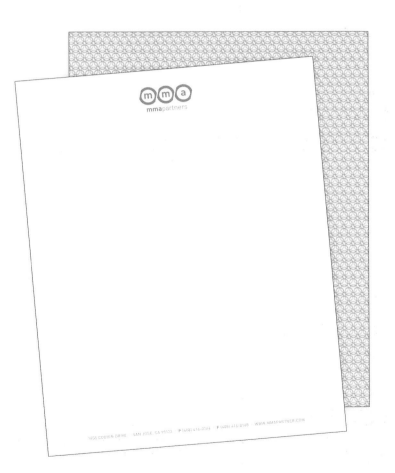

CLIENT: MMA Partners

STUDIO: Satellite Design
ART DIRECTOR: Amy Gustincic
DESIGNER: Amy Gustincic

CONCEPT: Logo and stationery for a print and packaging logistics management company. The circular forms that contain the company's initials convey the drums and rollers of a printing press.

CLIENT: The Bigger Know

STUDIO: Arsenal Design, Inc.
DESIGNER: Mark Raebel

CONCEPT: Business consultants that offer a greater knowledge — education is on the horizon.

CLIENT: Red Spade

STUDIO: Richard Zeid Design
DESIGNER: Richard Zeid

CONCEPT: Red Spade is a web site usability consulting firm. From the name through their web site, the logo and brand of red spade was all about building from the ground up. The spade, an essential tool to dig a foundation, acted as the perfect icon for the company and its mission.

CLIENT: US Navy

STUDIO: Arsenal Design, Inc.
DESIGNER: Mark Raebel

CONCEPT: Community Support Program — Northeast, the family support wing for Navy personnel in the US Northeast region.

CLIENT: The Fabric Connection

STUDIO: Arsenal Design, Inc.
DESIGNER: Mark Raebel

CONCEPT: Classical typeface simply using scale to create a hierarchy of read. The "i" dot changes color to represent each designer's signature color.

CLIENT: The Black Pig

STUDIO: The Black Pig
DESIGNER: The Black Pig

CONCEPT: A photographic image combines with the name set in a simple yet elegant typeface to clearly convey the name of this UK-based branding agency.

CLIENT: VH1 Save the Music Foundation

STUDIO: Alexander Isley, Inc.
CREATIVE DIRECTOR: Alexander Isley
MANAGING DIRECTOR: Aline Hilford
DESIGNER: George Kokkinidis

CONCEPT: This logo is a redesign of the identity for the Save the Music Foundation to mark their 10th anniversary. The old logo included a child playing a trumpet and we kept the trumpet element.

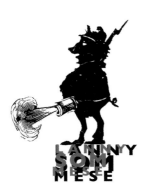

CLIENT: Sommese Design

STUDIO: Sommese Design
ART DIRECTOR: Lanny Sommese
DESIGNER: Lanny Sommese

CONCEPT: In order to separate the illustration/image-making realm from the design realm of Sommese's work, he wanted a logo that, similar to many of his images, got in your face and screamed ATTITUDE. That was his personal mandate.

Then, while working on a poster, by chance he happened to place a cut out piece of one image — an old engraving of a shooting cannon — onto another — an engraving of a pig/soldier he had snipped form an aged clip book. It suddenly occurred to Sommese that he had a new logo for himself: a warmonger mindlessly following his spewing cannon.

According to Sommese, it was the perfect mix of IN YOUR FACE machismo, power, bawdy bravado, burlesque and sex. All he had to do was paste them together as one unified image/mark. He left the cut marks to enhance the rawness of the statement and added some braggadocio copy set to a rough-honed typographic treatment that reverberates as the cannon roars, to literally push the idea off the edge of the page and into the hands of his audience.

NCAR

CLIENT: Local Girl Gallery
STUDIO: Little Jacket
DESIGNER: Joe Parlett
CONCEPT: Brand Mark for Local Girl Gallery in Lakewood Ohio.

CLIENT: Mike Bratton Voice Guy
STUDIO: Little Jacket
DESIGNER: Ken Hejduk
CONCEPT: Brand Mark for voice talent Mike Bratton.

CLIENT: National Center for Atmospheric Research, operated by the University Corporation for Atmospheric Research under sponsorship of the National Science Foundation
STUDIO: Robert W. Taylor Design, Inc.
ART DIRECTOR: Robert W. Taylor
DESIGNERS: Robert W. Taylor, Clyde Mason, Rene Bobo
CONCEPT: The challenge in the design of the logo for NCAR was to find a way to express the earth's atmosphere, something very ethereal, in a tangible way. Using a unique geometric shape and soft gradations of color, Taylor was able to create a logo that graphically captures a glimpse of the earth's surface at dawn, the atmospheric layer and a small piece of solar space.

American Institute of Graphic Arts

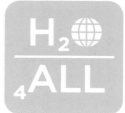

CLIENT: American Institute of Graphic Arts
STUDIO: Crosby Associates
CREATIVE DIRECTOR/DESIGNER: Bart Crosby
CONCEPT: Logotype and rebranding for AIGA, the National Association of Design Professionals.

CLIENT: Janet Macgillvray
STUDIO: Little Jacket
DESIGNER: Michael Burton
CONCEPT: The above logo and logo to the right are from a collaboration with the United Nations' environmental attorney Janet Macgillvray. The objective: mine fresh water for Africa via water sales in the U.S. Effectively, when you make a ripple in the U.S., the effects are doubled overseas.

CLIENT: Date Sense
STUDIO: Arsenal Design, Inc.
DESIGNER: Mark Raebel
CONCEPT: A logo designed for a unique technically-driven dating service that captures client information on a personal ID card.

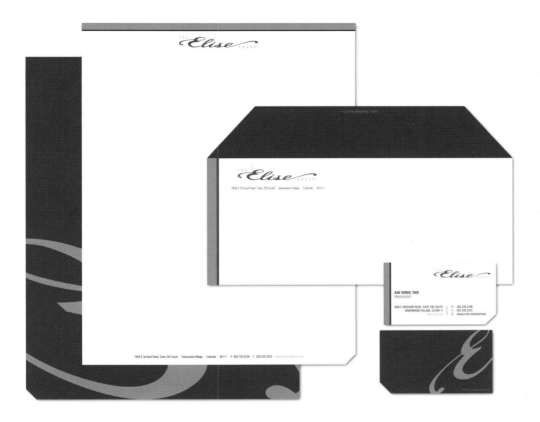

CLIENT: The Elise Group

STUDIO: Cranium Studio
PRINCIPAL/CREATIVE DIRECTOR: Alex Valderrama
DESIGNER: Andrew Zareck

CONCEPT: This newly-formed company needed to convey exceptional service in the hospitality consultation marketplace. The font was hand-drawn to communicate experience, integrity and a high level of service. The color selection communicates a strong, stable, high-end company. The corporate colors along with the tab notch are incorporated throughout all pieces to clearly represent cohesion.

Miller Amp Design

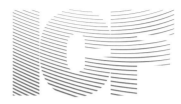

CLIENT: Micki's Mat

STUDIO: Arsenal Design, Inc.

DESIGNER: Mark Raebel

CONCEPT: Making it fun to do laundry, Micki's Mat logo plays with colors and typography found in detergents, and employs the use of bubbles to signify soap and cleanliness.

CLIENT: Miller Amp Design

STUDIO: Little Jacket

DESIGNER: Joe Parlett

CONCEPT: Brand Mark for Mick Miller, a custom guitar amplifier designer.

CLIENT: ICF - International Capital Funding

STUDIO: Sylvia Vaquer Design

CONCEPT: This logo for a mortgage firm is formed from the thin lines that render printed money;. The counter within the letter C shapes a key: the key to your home.

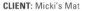

CLIENT: NuShop

STUDIO: Rachel Caldwell Design

ART DIRECTOR: Rachel Caldwell

CONCEPT: An approachable and friendly logo for a personal shopping service.

CLIENT: Town of Breckenridge, Colorado

STUDIO: Design Workshop

SENIOR DESIGNER: Kelan Smith

ASSOCIATE IN CHARGE: Steven Spears

CONCEPT: As the first step in implementing the revitalization of Breckenridge's historic Main Street, Design Workshop provided a bolder new logo for its bus stops. The design was influenced by historic typefaces used in 19th century posters and painted building advertisements.

CLIENT: Grab Carpet Maintenance System

STUDIO: Arsenal Design, Inc.

DESIGNER: Mark Raebel

CONCEPT: A logo designed for carpet cleaning agent, retro in style, with a can-do attitude.

punch

CLIENT: PUNCH

STUDIO: PUNCH
**CREATIVE DIRECTION, ART DIRECTION, DESIGN,
COPY:** The PUNCH Creative Team

CONCEPT: The PUNCH design team took advantage of the fact that the characters in the word 'punch' could all be created from the same basic "U" shape when rotated. The "U" character was generated as vector art and the rounded corners added to soften the look. The addition of an ascender and descender for the 'P' and 'H' finished it off, and orange was chosen to symbolize their energy and youthfulness.

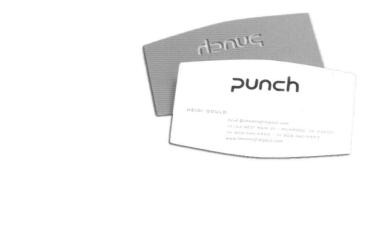

The Business Card: In looking for ways to convey their assets in the card design, they chose a shape that would "punch" out of a stack of normal sized cards on both the top and bottom. The blind laser die cut was implemented to give the card an additional visual impact.

CLIENT: Sommese Design

STUDIO: Sommese Design
ART DIRECTORS: Lanny Sommese, Kristen Sommese
DESIGNERS: Lanny Sommese, Pete Sucheski, John Henirch
ILLUSTRATION: Lanny Sommese

CONCEPT: The interlocking female/male logo image relates to the tight interrelationship of Kristin and Lanny Sommese. By altering the ubiquitous isotope symbols they were able to create a single image that related to the interactivity of their personal and professional lives while, at the same time, acting as a logo for each individually, depending on which end was up.

CLIENT: IPC

STUDIO: BrandSavvy, Inc.
ART DIRECTOR: Karl Peters
DESIGNER: Marcus Fitzgibbons, Jeff Petersen

CONCEPT: IPC is a world-wide membership organization of printed chip producers and engineers. The logo depicts the global aspect of the organization and reveals to the viewer its other side with a yellow stroke, representing the multi-faceted, dimensional aspects of the organization.

CLIENT: The Keating Group

STUDIO: Richard Zeid Design
DESIGNER: Richard Zeid

CONCEPT: An innovator in the real estate development arena, The Keating Group prides themselves on moving from cutting edge high-rise projects to single family homes. This thinking was reflected in the mark, incorporating arrows in the modified and distinct K letterform, yet combining into a solid square emblem.

CLIENT: Desirability

STUDIO: Gouthier Design: a brand collective
DESIGNERS: Gouthier Design Creative Team

CONCEPT: Desirability is a Christian marriage and intimacy counselling office. The logo makes reference to the lovers in the Song of Songs as gazelles. The stationery is designed as a folding self-mailer for cost purposes.

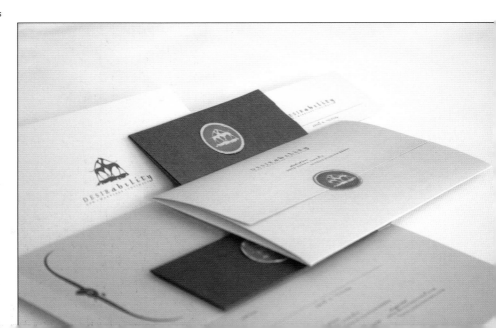

CLIENT: North Shore Dairy

STUDIO: Kern Design Group, LLC
DESIGNER: John Ferris

CONCEPT: The identity for this suburban Chicago dairy delivery service utilizes the waves of Lake Michigan, imagery not normally associated with dairy products.

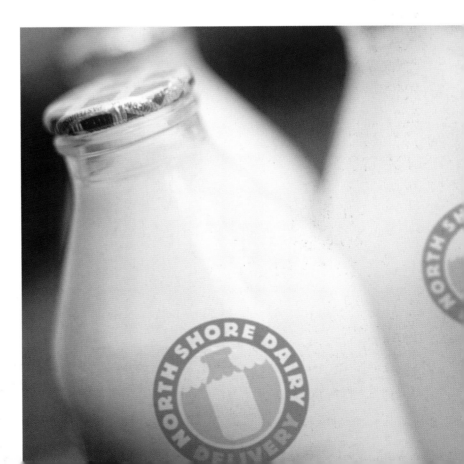

SACRED TREE
holistic healthcare and spa

CLIENT: Sacred Tree, Holistic Healthcare and Spa

STUDIO: Spin Creative Group
CREATIVE DIRECTOR: Brigette Schabdach
DESIGNER: Elizabeth Litwiller
ILLUSTRATOR: Elizabeth Litwiller

CONCEPT: For centuries, trees have been accorded a state of reverence, healing and vitality in cultures around the world. Trees provide a place for communities to gather where they can find healing, power, wisdom and security. Sacred Tree evolved from this ancient philosophy. Sacred Tree's objective is to provide healthcare, healing, wellness and education to their patients, community and beyond. This illustrated tree was created in these beliefs. It is in a shape of a circle representing oneness, completion, wholeness or coming full circle.

CLIENT: Wright IMC

STUDIO: Arsenal Design, Inc.
DESIGNER: Mark Raebel

CONCEPT: A play on words adds to this mark's appeal. The ascender of the "g" is separated to create a smile.

Carolina Clinical Education Consortium

CLIENT: The Carolina Clinical Education Consortium

DESIGNER: Gunnar Swanson

CONCEPT: The Carolina Clinical Education Consortium links physical therapy and physical therapy assistant students with clinical opportunities in North and South Carolina. The communication goals were to portray medical professionalism, binding or bringing together, and geography. The dogwood flower is the symbol of North Carolina and the palmetto tree/moon image is the symbol of South Carolina and, with the knot, forms a gestalt of a caduceus.

CLIENT: Our House of Portland

STUDIO: Jeff Fisher LogoMotives
DESIGNER: Jeff Fisher

CONCEPT: Our House of Portland, a residential care facility for people with AIDS, had been represented with the same dated identity for years. In re-designing the image, some reference to the old logo needed to be retained. The new icon was determined by the roof line of the new structure. The type used in the logo was predetermined by its use on all structural signage.

CLIENT: RSI

STUDIO: BrandSavvy, Inc.
ART DIRECTOR: Karl Peters
DESIGNERS: Scott Mahlmeister

CONCEPT: Retirement Strategies & Investments provides sound financial advise to a diverse set of clients. The logo depicts the turnkey set of products and services that they provide, while also representing diversity in solutions and the timely manner in which they work.

CLIENT: Balaboosta Delicatessen

STUDIO: Jeff Fisher LogoMotives
DESIGNER: Jeff Fisher

CONCEPT: The oval in this identity is consistent in the logos for all of the owner's restaurants. The colors and tile motif come from the floor of the late 1800s building in which the restaurant is housed.

Johnson Controls

CLIENT: Johnson Controls

STUDIO: Lippincott
CREATIVE DIRECTOR: Rodney Abbot
DESIGNERS: Rodney Abbot, Christian Dierig, Bogdan Geana

CONCEPT: Johnson Controls has been known for decades as a top supplier to the automotive industry with a rich heritage and a strong reputation for optimizing building efficiency. The logo represents vitality and energy. The interweaving rings, or "waves", reflect the exchange of ideas, dialogue and engagement with customers and employees. They are an abstraction of the initials "JC" and can be read as the movement of air, the transfer of energy, interaction and wireless transmission… recalling core elements of the businesses. It is also emblematic of the focus on sustainability and environmental responsibility.

Deep blue, in combination with the fluid color transition from bright blue to green in the symbol reflects both flexibility and creativity expressed by a professional, confident leader.

The logotype employs a modern sans serif typeface, custom drawn to reflect a contemporary, confident and approachable look. The bold weight and stacked alignment combines to add presence and distinction to the name.

CLIENT: Wana (formerly Maroc Connect)

STUDIO: Lippincott
CREATIVE DIRECTOR: Brendán Murphy
DESIGNER: Brendán Murphy
STRATEGY: Denis Bonan, Rune Gustafson, Kat Walker

CONCEPT: Bayn is an innovative local area network phone service in Morocco. Bayn is also a pre-pay service designed to democratize access to telecommunications in Morocco and to give control back to the Moroccan consumer.

The primary color, bright green, communicates a fresh approach, a new idea that clearly differentiates the brand from the established competition. The flexibility to lead with the Arabic or roman namestyle in the Bayn name allows the brand to adapt to its national and regional audiences.

CLIENT: North Back Café

STUDIO: Jeff Fisher LogoMotives
DESIGNER: Jeff Fisher

CONCEPT: The television show *Northern Exposure* meets a cross-dressing moose in this restaurant identity. The owner wanted a rustic sophistication to the logo, along with a moose with long eyeglasses.

CLIENT: Genevieve Leiper Photography

STUDIO: Saxony Creative Group
DESIGNER: Michael Peters & Saxony Creatives

CONCEPT: The logo reflects Genevieve Leiper's natural and sometimes puritan photography. The nature of the tree and subtext works well with the classic serifs of the title.

CLIENT: Lifestyle Designs

STUDIO: Arsenal Design, Inc.
DESIGNER: Mark Raebel

CONCEPT: Logo created for a home interior design group. A unique color combination adds distinction to a perfectly balanced logotype.

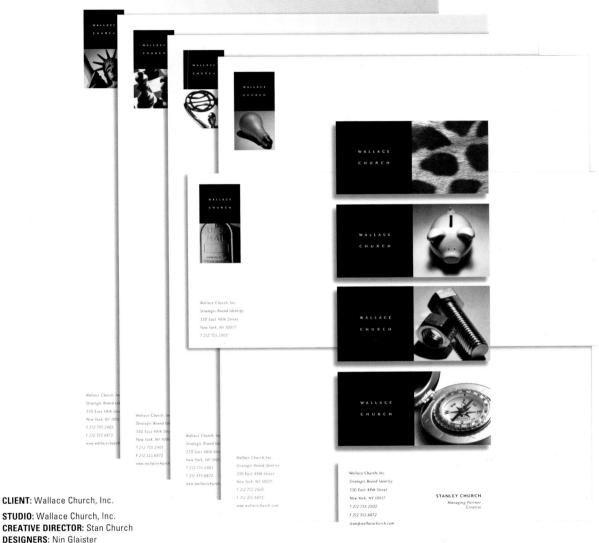

CLIENT: Wallace Church, Inc.

STUDIO: Wallace Church, Inc.
CREATIVE DIRECTOR: Stan Church
DESIGNERS: Nin Glaister

CONCEPT: In designing their own unique stationery, Wallace Church utilized images appropriate to their industry and location: New York City. Their business cards also feature photographic images; each one is unique, chosen to reflect each employee's individual interests or personality.

CLIENT: Mutual of Omaha
STUDIO: Crosby Associates
CREATIVE DIRECTOR/DESIGNER: Bart Crosby
CONCEPT: Logotype and rebranding created in 2002 for this provider of home, life, property, and casualty insurance.

CLIENT: Holland + Knight Charitable Foundation, Inc.
STUDIO: Jeff Fisher LogoMotives
DESIGNER: Jeff Fisher
CONCEPT: The Native Youth Internship Program places high school Native American youth in the office of the Holland + Knight law firm as interns during their senior year. The identity was designed to subtly convey the shape, look and colors of a traditional Native American blanket.

CLIENT: Eviciti
STUDIO: Crosby Associates
CREATIVE DIRECTOR/DESIGNER: Bart Crosby
CONCEPT: Eviciti is an internet strategy, marketing, and integration company.

CLIENT: Band of Writers
STUDIO: Gouthier Design: a brand collective
DESIGNERS: Gouthier Design Creative Team
CONCEPT: Logo for a group of 18 writers who pitch themselves to agencies and other creatives. The image is rendered as a monument to their craft: three confident silhouettes proudly brandishing their weapon of choice: the pen.

CLIENT: New Orleans Musician's Clinic
UNIVERSITY: Tyler School of Art / Temple University
PROFESSOR: Stephanie Knopp
DESIGNER: Heather Barney
BRIEF: The objective of this project was to redesign the logo for New Orleans' Musicians Clinic for its return to New Orleans after Hurricane Katrina. The mission of the clinic is to provide medical services to the city's professional musicians, most of whom do not have medical insurance.

CLIENT: New Orleans Musician's Clinic
UNIVERSITY: Tyler School of Art / Temple University
PROFESSOR: Stephanie Knopp
DESIGNER: Lena Cardell

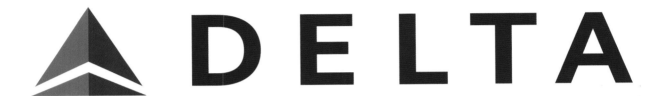

CLIENT: Delta Air Lines

STUDIO: Lippincott

CREATIVE DIRECTOR: Connie Birdsall, Peter Dixon

DESIGNERS: Adam Stringer, Kevin Hammond, Michael Milligan, Fabian Diaz

CONCEPT: Delta Air Lines is the third largest US carrier with more than 47,000 employees.

To coincide with the airline's emergence from a Chapter 11 restructuring, Delta came to Lippincott for a strategic reposition, image revitalization and customer experience redesign.

The new logo was designed to convey a renewed strength and confidence and modernization of the airline to both customers and its employees. The simplified all-red symbol and all-uppercase logotype visually reinforce a more sophisticated, directed and globally appropriate expression while being considerate of the airlines extensive heritage. The Delta symbol is further leveraged through a dynamic cropped livery treatment that speaks to momentum, growth and optimism.

The new identity — applied to a Boeing 757 and revitalized elements of the customer experience — were unveiled to 5,000 employees at a hanger event in Atlanta and thousands of others around the world via live satellite feed.

Lippincott's customer experience implementation rolled out immediately following the launch. The look and feel of the terminals is being dramatically transformed — from new outdoor signage and check-in areas to gates and baggage claim areas — to reflect the new brand identity. Elements of the in-flight experience such as monitor displays, menus, and place-settings have also been redesigned.

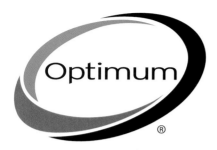

Optimum
voice

Optimum
Lightpath

interactive
Optimum

Optimum
online

CLIENT: Optimum Brand Services, Cablevision

STUDIO: Sterling Brands
DESIGNERS: Stephen Dunphy, Marcus Hewitt, Marc Sanpogna

CONCEPT: The objective was to develop a suite of identities for Cablevision's Optimum Services. The focus was on the three core attributes of speed, technology and ease of use. The identities leverage contemporary iconic letterforms with a spirited simplicity to appeal to a broad audience.

CLIENT: Vale

STUDIO: Lippincott
CREATIVE DIRECTOR: Connie Birdsall
DESIGNERS: Adam Stringer, Daniel Johnston, Brendán Murphy, Carlos Dranger, Isa Martins

CONCEPT: Vale is the second largest mining company in the world and one of Brazil's biggest and most admired companies. In the wake of several international acquisitions, such as INCO in Canada and AMCI in Australia, Vale came to Lippincott, and their Brazilian partner Cauduro Martino, to address several outstanding branding issues; including brand strategy, positioning, naming, message development, brand architecture, logo development and launch planning.

To date, Vale had gone to market under many names: CVRD, Rio Doce, Vale, Companiha do Vale Rio Doce. A single name, Vale, was selected to unify the company — and all of its new acquisitions under one umbrella.

An additional priority for Vale was to highlight its profile as a mining company that was not only focused on growth and expansion, but also committed to social and environmental responsibility. Through a brand repositioning focused on humanizing the industry by highlighting how minerals are the essential ingredients in all our lives, Lippincott helped Vale create a compelling positioning that distinguishes it from its competitors.

The company's new visual identity aims to consolidate its image as a Brazilian company and increasing global presence, highlighting its distinctive position. The symbol, a "V" monogram, conveys visual qualities of landscape, discovery, mining and a circular, reciprocal type, motion — strength, elegance and humanistic in a single expression, Brazilian in its colorization.

CLIENT: TraveLady Media

STUDIO: Jeff Fisher LogoMotives
DESIGNER: Jeff Fisher

CONCEPT: In updating an existing logo, a travel bag in the image became a television representation for a company promoting video media for women who travel.

CLIENT: Women for Women

DESIGNER: Steve Gibson

CONCEPT: Women for Women are a very unique charity. Women-only fundraisers sponsor female scientists at Imperial College London. They are engaged in extremely valuable childbirth research. A large part of the research is now genetic study. And after some lengthy concept development Gibson saw the opportunity to unite two Ws in the DNA helix. It was a perfect representation of the union of the fundraisers and the scientists and also gave us the necessary medical significance.

CLIENT: Students Against Genocide in Africa (S.A.G.A.)

ART DIRECTOR: Ryan Russell
DESIGNER: Ryan Russell

CONCEPT: Students Against Genocide in Africa is a non-sanctioned student group, and works to raise awareness of ongoing genocide that plagues several regions in Africa. The red open palm serves as both a symbol for stop, as well as a plea for help from the philanthropic community. The reversed silhouette of Africa within the palm gives this mark a specific context.

CLIENT: Kristie Agee

STUDIO: jamidesign
DESIGNER: Jamie Anderson

CONCEPT: This logo is for a swing band singer who is the queen of her craft, yet has a big generous heart. The sceptre-like image with a crown on top lends her this air besides the obvious heart shape in the middle.

CLIENT: Edge Advantage, Inc.

ART DIRECTOR: Ryan Russell
DESIGNER: Ryan Russell

CONCEPT: This mark was designed for Edge Advantage Inc., an operational and financial consulting firm. This particular establishment was looking to create an identity that is bold, powerful, and dynamic, and reflected its name.

CLIENT: Digital Composition, Inc.

STUDIO: Crosby Associates
CREATIVE DIRECTOR/DESIGNER: Bart Crosby

CONCEPT: Digital Composition, Inc. is a typographer and typographic consultancy.

TEMPO

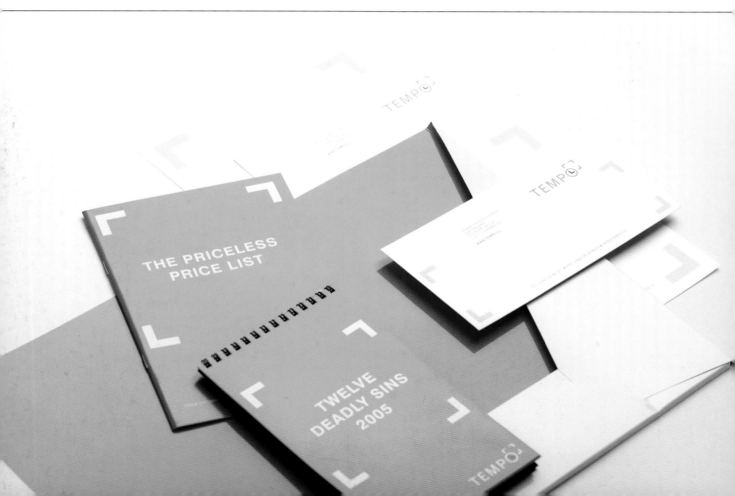

CLIENT: Tempo

STUDIO: Vidale-Gloesener
CREATIVE DIRECTOR: Tom Gloesener
DESIGNER: Silvano Vidale

CONCEPT: Tempo is a recently created advertising-management agency dedicated to the commercialisation of materials in line with the mind-set of their publisher. Pinpoint targeting of media, original advertising methods and a genuine interest in the client, plus a dedicated and smiling team, are what make Tempo stand out. Born of the association between the publisher Mike Koedinger and Aurelio Angius, the agency today represents the following magazines, guides, websites and electronic newsletters: paperJam, Rendezvous, Flydoscope, Désirs, Explorator, Index.

CLIENT: Foreman Electric

STUDIO: Mazziotti Design

DESIGNER: Jordon Mazziotti

CONCEPT: The objective was on making a clean memorable typographic treatment of the company name. This logo is versatile and can be presented in color, black and white and with our without the box.

CLIENT: Koch Creative Group

STUDIO: Koch Creative Group

SENIOR ART DIRECTOR: Jeff Chilcoat

ART DIRECTOR: Dustin Commer

DESIGNERS: Richard Bachman, David Hahn

CONCEPT: In order to create a mark that would be recognizable in a corporate environment, Koch used the letters K and C in a very abstract form that also created an arrow shape near the middle.

The arrow leading inward, represented that Koch is an in-house agency and work inside Koch Industries. The bold red and black were chosen to offset all the white and blue employees were familiar with on other internal logos.

CLIENT: Visible Voice Books

STUDIO: Little Jacket

DESIGNER: Michael Burton

CONCEPT: Visible Voice Books is an independently-owned book store in the Tremont neighborhood of Cleveland. The exclamation marks also serve as books stacked on a shelf.

CLIENT: Nerd Nutz

STUDIO: Mazziotti Design

DESIGNER: Jordon Mazziotti

CONCEPT: Nerd Nutx is a computer IT company that wanted an edgy logo. They did not want to be like other tech companies with cliché images.

CLIENT: Lumagine

STUDIO: Mazziotti Design

DESIGNER: Jordon Mazziotti

CONCEPT: Mazzioti used the lightbulb to signify the company's innovation. They extended the line to integrate the bulb with text in a subtle way.

CLIENT: WMMC Griffin Internet Radio

STUDIO: Mazziotti Design

DESIGNER: Jordon Mazziotti

CONCEPT: A logo for a Internet radio system headquartered at Marymount Manhattan College in New York. The mark utilizes the iconic radio tower with signals emanating from its peak to convey the power of radio as a communication medium.

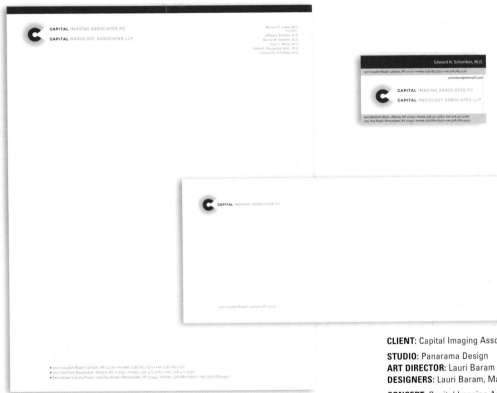

CLIENT: Capital Imaging Associates

STUDIO: Panarama Design
ART DIRECTOR: Lauri Baram
DESIGNERS: Lauri Baram, Maureen Mooney

CONCEPT: Capital Imaging Associates is an expanding practice of radiologists that wanted to update its 1970s-looking graphic identity. Using the initial C as the centerpiece of the logo and creating a shape reminiscent of both the shape of equipment used and the rays emitted along with a cool almost metallic color palette gave the client the high-tech look they desired.

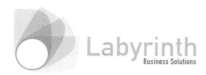

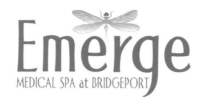

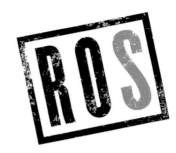

CLIENT: Labyrinth Business Solutions

STUDIO: Arsenal Design, Inc.
DESIGNER: Mark Raebel

CONCEPT: The shape of the "L" was created out of the interior negative shape of the "a" with overlapping transitional pastel colors symbolizes the companies progressive nature.

CLIENT: Emerge Medical Spa at Bridgeport

STUDIO: Jeff Fisher LogoMotives
DESIGNER: Jeff Fisher

CONCEPT: The Emerge logo incorporates the traditional iconography of dragonfly imagery. The input of a psychic, and use of runes within the design, were part of the design process.

CLIENT: IEG, Inc.

STUDIO: Crosby Associates
CREATIVE DIRECTOR/DESIGNER: Bart Crosby

CONCEPT: Crosby created this logo for a published workbook to help measure, justify and maximize the *return on sponsorships* and partnerships, thus ROS.

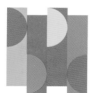

CLIENT: Palm Beach Pediatric Dentistry

STUDIO: Crosby Associates
CREATIVE DIRECTOR: Bart Crosby
DESIGNER: Malgorzata (Gosia) Sobus

CONCEPT: Palm Beach Pediatric Dentistry is a leading-edge practice that delivers state-of-the-art oral health care to the pediatric population from birth through their teenage years.

CLIENT: Constant Artists Management

STUDIO: Little Jacket
DESIGNER: Michael Burton

CONCEPT: Brand Mark for a LA-based music management company. The implementation of gear imagery plays with the acronym of the company: CAM.

CLIENT: Evergreen Mtn. Casino

STUDIO: Little Jacket
DESIGNER: Michael Burton

CONCEPT: Brand Mark for a campaign to propose a casino in Maine. The mark utilizes formal characteristics of both the geographical region of Maine (the color green, mountaintop) and casino / cardplay (the ace symbol).

SOLITE | Lightweight+heavy Performance
Aggregate Geotechnical Applications

SOLITE | Lightweight+heavy Performance
Aggregate Geotechnical Applications

www.solitellc.com

CLIENT: Solite

STUDIO: Response Marketing Group
CREATIVE DIRECTOR: Tommy Lee

CONCEPT: Tagline: Lightweight ... Heavyweight...
Lee wanted to capture their tagline in the visual
form of a logo. And by emphasizing the 'O,' it does
not capture the concept of the name "SoLite." It
reads as "SO-lite."

SOLITE | 8042 Hampton Station Court
Chesterfield, Virginia 23832

SOLITE | Lightweight+heavy Performance
Aggregate Geotechnical Applications

Steven C. Kerr, P.E.
Territory Manager
skerr@solitellc.com

8042 Hampton Station Court
Chesterfield, Virginia 23832
757.494.5200, 757.545.3793 fax.
804.432.2684 mobile
www.solitellc.com

8042 Hampton Station Court, Chesterfield, Virginia 23832. 757.494.5200, 757.545.3793 fax.

Baby Travel Rentals, Inc.

CLIENT: Baby Travel Rentals, Inc.
STUDIO: PLAID Studios
DESIGNER: Matt Woolman
CONCEPT: Identity mark and stationery for Baby Travel Rentals, Inc., a full-service baby and toddler equipment rental company that provides high-quality, trusted name-brand products for the travelling parent visiting the Richmond, Virginia area: *Gear for babies on the go*. The mark was modeled after the owners' son, and conveys a contemporary cupid with a suitcase instead of bow & arrow. The baby is running, which signifies "babies on the go." The darker color palette communicates to parental wisdom rather than childlike whimsy.

CLIENT: BrightHeart Veterinary Centers
STUDIO: Lippincott
CREATIVE DIRECTOR: Rodney Abbot
DESIGNER: Sam Ayling
CONCEPT: This national chain of veterinary centers based on a commitment to "Highest standards. Exceptional care. Healthier pets." The logo is an inspired depiction of a pet's toy, evoking both the restoration of health and the playful moments when humans and animals joyfully interact. The suggestion of medical professionalism is enhanced through crisp typography, and a clean layout.

CLIENT: FCCA
STUDIO: Response Marketing Group
CREATIVE DIRECTOR: Tommy Lee
CONCEPT: The FCCA is a Federal Communication Commission (FCC) certified frequency coordinator for all public safety frequencies, including those in the 700 MHz and 800 MHz bands. They provide a full range of radio communications services for forestry and conservation agencies, police, fire/EMS and local government. A two-color palette — blue, green — and simple line art illustrates what FCCA does in abstracted form.

CLIENT: Surface Studio
STUDIO: Go Welsh
ART DIRECTOR: Craig Welsh
CONCEPT: This logo represents a company that provides high-end faux finishing and surface treatments. A simple typographic treatment of the company name and iconic brush image completes the logo.

CLIENT: Gamers Insight Group
STUDIO: Mazziotti Design
DESIGNER: Jordon Mazziotti
CONCEPT: An ambigram rendered in a technologically styled typeface has immediate visual impact for this gaming organization.

CLIENT: Indian River Medical Center
STUDIO: BrandSavvy, Inc.
ART DIRECTOR: Karl Peters
DESIGNER: Karl Peters
CONCEPT: This logo depicts the beautiful location of Vero Beach, Florida where Indian River Medical Center resides: the treasure coast waters, the blue sky and the sandy beaches. The tranquil water soothes the healthy mind and provides instant recognition for anyone looking for quality healthcare in Vero Beach.

CLIENT: ascender

DESIGNER: Lindsay Story

CONCEPT: The identity system for Ascender, proposed graphic design firm, was designed as Story's final project for her communication design course at Virginia Commonwealth University. The square format of the stationery package creates a nice juxtaposition with the circle seal of the logo. This seal is repeated in a fun palette of colors an additional items, such as promotional cards, mugs, and packaging.

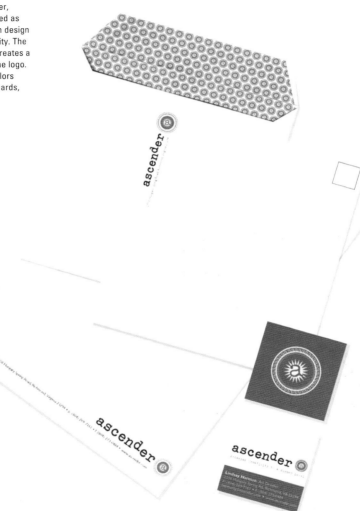

CLIENT: Robert W. Taylor Design, Inc.

STUDIO: Robert W. Taylor Design, Inc.
ART DIRECTOR: Robert W. Taylor
DESIGNER: Robert W. Taylor, Rene Bobo

CONCEPT: After years of designing logos for others without having one themselves, Taylor decided it was time for a change. Wanting to reflect the qualities of craft and personal pride of the Arts & Crafts movement of the late 19th C. they created their own company mark for the initials RWT.

CLIENT: Mazziotti Design

STUDIO: Mazziotti Design
DESIGNER: Jordon Mazziotti

CONCEPT: A self-portrait of sorts. The logo immediately identifies Jordan, the principal of Mazziotti Design.

CLIENT: Biotrek

DESIGNER: Gunnar Swanson

CONCEPT: Biotrek is a biology education venue at Cal Poly Pomona. The circle represents the orb of the sun, the cycles of nature, a single drop of water, but more directly, the field of a microscope, a scientist's view of seldom-seen parts of the biological world. The S-curve of the midline also mirrors the curved glass walls of Building 4, which houses the Biotrek programs.

The logotype is made of simple shapes, to harmonize with each of the diverse shapes of the natural world. Its top line and the variety of the letters model the multi-level canopy of the rainforest, or at smaller scale the canopy of California scrub. The descending angle of the "k" also suggests the pitch of the greenhouse roof.

CLIENT: cee3

STUDIO: Richard Zeid Design
DESIGNER: Richard Zeid

CONCEPT: cee3 is a graphic design firm dedicated to creating graphic, advertising, and web site design specifically for non-profit arts organizations. It also serves as a bridge/mentor studio for recent college graduates moving into professional practice.

CLIENT: Pure Equator

STUDIO: Pure Equator
DESIGNER: Pure Equator

CONCEPT: Pure Equator was formed in 2003 by two companies, Pure & Equator. Clients of this UK-based branding agency have said that their design is simple and effective = pure. Their logo mark conveys this with clean typography set within a square frame, and a cool blue and grey palette with the word "pure" dropped out to the white background.

CLIENT: Asparagus

STUDIO: Richard Zeid Design
DESIGNER: Richard Zeid

CONCEPT: Asparagus is a restaurant in Northwest Indiana that blends the flavors of Vietnam, Thailand, France and the Americas all in a cuisine that features asparagus. A formal mark was created using stalks of asparagus, pairing it up with a modern type treatment reflected the fusion of classic and modern.

jordon mazziotti
graphic designer
801.414.9473
jordon@mazziottidesign.com
mazziottidesign.com

ngisəb**ittoizzɐm**

mazziottidesign

jordon mazziotti
graphic designer
801.414.9473
jordon@mazziottidesign.com
mazziottidesign.com

mazziottidesign

mazziottidesign

mazziottidesign

CLIENT: Aramdyne Incorporated

STUDIO: Arsenal Design, Inc.

DESIGNER: Mark Raebel

CONCEPT: The suspension bridge symbol was created to communicate the concept of "bridging the gap" between engineers and creatives.

CLIENT: Mashreq Bank

STUDIO: Lippincott

CREATIVE DIRECTOR: Alex de Janosi

DESIGNERS: Jennifer Lehker, Sam Ayling

CONCEPT: As 'mashreq' translates to 'where the sign rises in the East', the identity conveys a rising sun and the new positioning of openness: the financial promise of "opening opportunities," the service promise of "opening access" and the more human, relationship promise of "opening up."

CLIENT: SK

STUDIO: Lippincott

CREATIVE DIRECTOR: Connie Birdsall

DESIGNER: Brendán Murphy

CONCEPT: SK is one of Korea's largest conglomerates linking over 40 companies from telecom, to energy, to life sciences. The SK identity was created as part of an initiative to symbolize the repositioning of SK as a leading global enterprise for the 21st century. The new logo is a combination of symbolic forms that suggest the uplifting and transformational qualities of a kite or butterfly and the innovation of a satellite. The form creates the illusion of the wings soaring upward to reflect SK's progressive nature and strong commitment to innovation, high quality standards and growing global reach. Red was selected as a logo color to convey the passionate, energetic, proactive and dynamic qualities of SK's personality and orange emphasizes SK's commitment to happiness and customer friendly orientation.

CLIENT: Success in Order

STUDIO: Arsenal Design, Inc.

DESIGNER: Mark Raebel

CONCEPT: Making order out of chaos – these shapes represent order, the feminine colors represent that this consultancy is a woman-owned organization.

CLIENT: Gold Cafe

STUDIO: Go Welsh

ART DIRECTOR: Craig Welsh

DESIGNER: Ryan Smoker

CONCEPT: Logo for Gold Cafe, a hybrid bank branch and full-service coffee house.

CLIENT: ECO INNOVATION for Sun Micro Systems

STUDIO: Celery Design Collaborative
DESIGNERS: Brian Dougherty, Stephanie Welter

CONCEPT: A simple logo treatment to reflect Sun's sustainability story. The mark is not associated with a specific product, but represents an authentic eco-story or eco-initiative. Used on communication materials, print collateral, web sites, Powerpoint presentations, etc.

CLIENT: Superheroes Needed

STUDIO: Little Jacket
DESIGNER: Michael Burton

CONCEPT: This is a proposed brand mark for *Superheroes Needed,* a campaign to educate children about environmental issues.

CLIENT: Spectrum Health

STUDIO: Crosby Associates
CREATIVE DIRECTOR/DESIGNER: Bart Crosby

CONCEPT: Logotype and rebranding for this Grand Rapids-based health system.

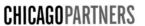

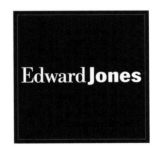

CLIENT: Captive Resources, LLC

STUDIO: Crosby Associates
CREATIVE DIRECTOR: Bart Crosby
DESIGNER: Joana Vodopivec

CONCEPT: Captive Resources, LLC is a member-owned captive insurance group.

CLIENT: CHICAGO PARTNERS

STUDIO: Crosby Associates
CREATIVE DIRECTOR: Bart Crosby
DESIGNER: Joana Vodopivec

CONCEPT: Chicago Partners is a group of leading academic and industry professionals with backgrounds in economics, accounting, and finance. They provide economic analyses of legal and business issues for law firms, corporations, and government agencies.

CLIENT: Edward D. Jones & Company

STUDIO: Crosby Associates
CREATIVE DIRECTOR/DESIGNER: Bart Crosby

CONCEPT: logotype and rebranding for this international investment firm.

CLIENT: Cypress Interior Design

STUDIO: Gouthier Design: a brand collective
DESIGNERS: Gouthier Design Creative Team

CONCEPT: Gouthier developed a set of identifiers because this interior design firm's work is eclectic. Roots growing off of the table, chair and other items are linked to the idea of a cypress tree.

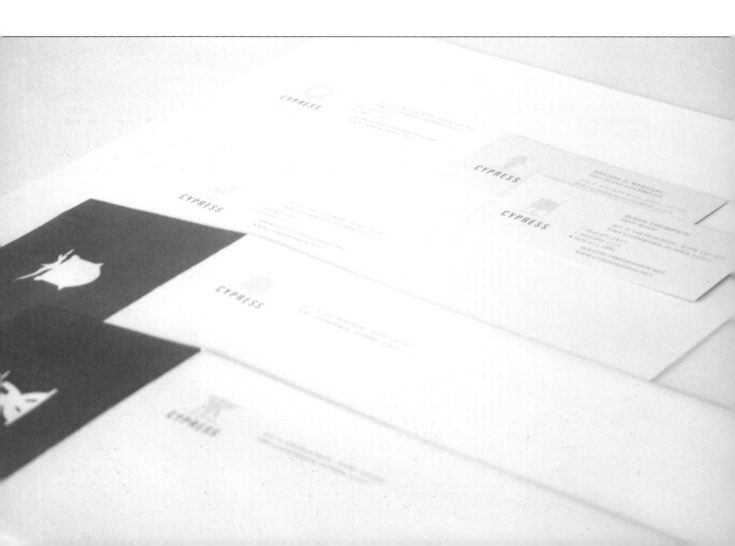

Unified Grocers ℠

CLIENT: Unified Grocers

STUDIO: BrandSavvy, Inc.
ART DIRECTOR: Karl Peters
DESIGNERS: Karl Peters

CONCEPT: Unified Grocers is a membership organization for the retail store industry. With a fleet of over 1,000 vehicles, they ship and warehouse just about anything you would find in a grocery store. The logo is meant to be a vessel, which in application is full of product. The U vessel in application holds products, anything from frozen carrots, to noodles, to potato chips and changes from one application to the next.

CLIENT: Oregon Health & Science University

STUDIO: BrandSavvy, Inc.
ART DIRECTOR: Karl Peters
DESIGNERS: Marcus Fitzgibbons, Scott Surine

CONCEPT: This logo for the Oregon Health and Science University depicts the passion that the educational component of the organization has towards its students, faculty and community. The flame also depicts the compassion towards the patients of the health care component of the organization.

CLIENT: Redletter Events

DESIGNER: Justin K. Howard

CONCEPT: The objective focuses on visually communicating a "red letter day" — originally derived from the red marking of holy days on church calendars, now being used to refer to days of special significance. The solution alludes to a calendar, while creating a distinct typographic mark.

CLIENT: Tampa Bay Heart Institute

STUDIO: BrandSavvy, Inc.
ART DIRECTOR: Karl Peters
DESIGNER: Scott Surine

CONCEPT: This logo for the Tampa Bay Heart Institute depicts the serious nature of the heart care given by expert doctors a TBHI. No valentines, just aortas and ventricles...

RedLine

CLIENT: RedLine

STUDIO: BrandSavvy, Inc.
ART DIRECTOR: Karl Peters
DESIGNERS: Karl Peters, Marcus Fitzgibbons

CONCEPT: RedLine is an artist incubator in Denver, Colorado. The logo depicts the idea of crossing over the redline leaving what you know about art at the door and opening your eyes to something new. The 'R' in the symbol breaks from the normality of the other shapes, non-conforming and artistically rendered.

CLIENT: Global Market Development Group (GMDC)

STUDIO: BrandSavvy, Inc.
ART DIRECTOR: Karl Peters
DESIGNER: Marcus Fitzgibbons

CONCEPT: GMDC is a membership organization that provides tools and education for its members in the retail store arena. The logo depicts leading members to success, while the regal purple and gold speak to the quality and devotion that is given to the process.

brand **U**

For the Brand New.

neo

windstream

CLIENT: Brand U

STUDIO: Arsenal Design, Inc.

DESIGNER: Mark Raebel

CONCEPT: A simple mark for a company dedicated to branding others.

CLIENT: Neo

DESIGNER: Steve Gibson

CONCEPT: Neo are home automation specialists that specify and install the latest audio, video, lighting, climate and security technologies. Gibson's intention was to create a mark that suggested technology used in the home where much of it was connected together and designed to interact. The silver patterns found on circuit boards curve and connect to form the shape of a house above the company name.

CLIENT: Windstream

STUDIO: Lippincott

CREATIVE DIRECTORS: Connie Birdsall, Brendán Murphy

DESIGNER: Brendán Murphy

CONCEPT: Windstream was formed through the spinoff of Alltel's landline business and merger with VALOR Telecom. Windstream provides advanced local communications and entertainment products and services through phone, broadband and digital TV services. The logo for this new company conveys the value-added services this new company provides.

CLIENT: Taskmasters

STUDIO: Arsenal Design, Inc.

DESIGNER: Mark Raebel

CONCEPT: Strong basic mark to represent a handy man organization symbolized by basic hand tools and simple shapes.

CLIENT: Dallas Media Center

STUDIO: Arsenal Design, Inc.

DESIGNER: Mark Raebel

CONCEPT: The radiating circles around the dot of the "i" represent broadcasting and the colors and star to symbolize Texas.

CLIENT: The Home Depot – Balance Protector

STUDIO: Arsenal Design, Inc.

DESIGNER: Mark Raebel

CONCEPT: The shield was used as a symbol of protection, fortification and quality.

nextstep

CLIENT: North Castle Partners

STUDIO: Kern Design Group, LLC
DESIGNER: John Ferris

CONCEPT: Nextstep Logo and Stationery: Identity, stationery and collateral materials developed for Nextstep, a newly-formed digital division of a teen-focused advertising agency.

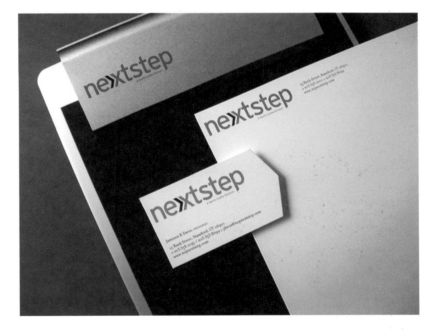

AQUIDNECK
LAND TRUST

CLIENT: Aquidneck Land Trust

STUDIO: Arsenal Design, Inc.

DESIGNER: Mark Raebel

CONCEPT: With nature and the environment in mind, the use of a green palette along with a leaf allows this logo to strengthen the identity of an organization dedicated to preserving land.

CLIENT: Produced by Trevor Horn

DESIGNER: Steve Gibson

CONCEPT: Some projects literally present the visual solution when the client is already famous for a particular attribute. In this case, world-renowned music producer Trevor Horn was famous for his big glasses. He always had been the "speccy genius" in the music studio. Gibson simply added some aural "vibration" by overlaying and offsetting the logo upon itself. The logo was designed for a 25th anniversary concert and was used across everything from a double album, to concert graphics to merchandising.

CLIENT: Rivet

STUDIO: Doug Fuller, Logo & Identity Designer

CREATIVE DIRECTOR AND DESIGNER: Doug Fuller

CONCEPT: Rivet provides real estate and construction consulting to businesses buying or renovating office space. Coming from a construction background, the client wanted something that connoted strength and solidity.

CLIENT: Chameleon

STUDIO: Jeff Fisher LogoMotives

DESIGNER: Jeff Fisher

CONCEPT: Personal logo for a hairstylist who desired images of swirls, and a yin/yang reference, in her identity featuring a chameleon. The font is the historic Kells Round from P22, giving the logo a Celtic type treatment as requested by the client.

CLIENT: Neighborhood Service Center

STUDIO: Jeff Fisher LogoMotives

DESIGNER: Jeff Fisher

CONCEPT: Designed for the City of Portland, the Neighborhood Service Center logo identifies regional clearinghouses throughout the city making municipal service more accessible. The graphic of human forms creating building shapes was used to create a sense of working together in a community.

CLIENT: Norton Street Business Services

STUDIO: Fifth Letter

DESIGNER: Elliot Strunk

ILLUSTRATOR: Elliot Strunk

CONCEPT: Logo for business services company that literally thinks outside the box.

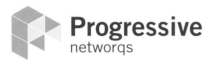

Progressive
networqs

CLIENT: Progressive Networqs

STUDIO: Response Marketing Group
CREATIVE DIRECTOR: Tommy Lee

CONCEPT: This very young and aggressive small business developer from Bank of America went back to Japan and set up a company that buys bankrupted older businesses that could not survive in the 21st century and reconstructs them keep it or re-sell.

Lee created a logo of forms that can be used to easily create all the letters in the alphabet, with the idea of unlimited progress in business re-development and re-construction.

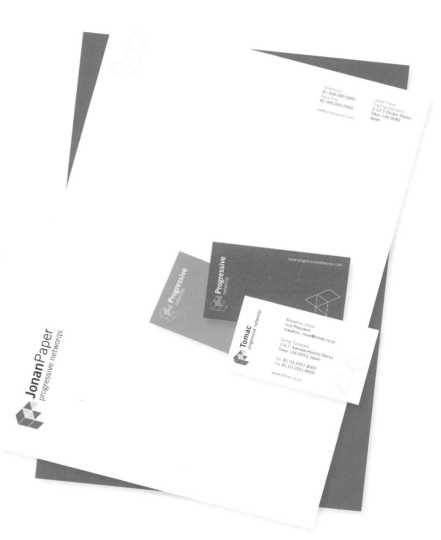

CLIENT: Bullnose Design

STUDIO: Bullnose Design
DESIGNER: Nicola Gee

CONCEPT: The name Bullnose comes from Lord Nuffield, who, if inflation is taken into account, gave more money to charity than any other British person. This logo was based on the shape of the Bullnose Morris car radiator.

CLIENT: Association for Responsible Inner Eastside Neighborhood Development

STUDIO: Jeff Fisher LogoMotives
DESIGNER: Jeff Fisher

CONCEPT: The AFriend logo was an effort used to identify a group of businesses, successful neighborhood activists and residents in their fight against "big box" store developments. Within the identity are symbolic representations of people working in unity, a river, inner city blocks and more.

CLIENT: El Paso Corporation

STUDIO: Sterling Brands
DESIGNERS: Clay Pullen, Marcus Hewitt

CONCEPT: The objective was to develop a new brand vision of El Paso during its passage from a "challenger" to an established energy leader. Sterling developed the positionings — the new path of energy value — and brought it to life with a new logo, brand identity system, print communications, environmental signage and launch advertising campaign.

CLIENT: VanderVeer Center

STUDIO: Jeff Fisher LogoMotives
DESIGNER: Jeff Fisher

CONCEPT: The VanderVeer Center logo is the centerpiece of the rebranding of the medical spa facility and its anti-aging services. The identity was intended to project a European, high-end image for the clinic.

CLIENT: Turner Renewable Energy

STUDIO: Sterling Brands
DESIGNER: Kim Berlin, Irina Ivanova, Brody Boyer, Monica Banks

CONCEPT: The objective was to develop a groundbreaking brand identity system for a truly unique energy company. Sterling designed a simple yet inspired identity and visual language program that portrays the sophisticated, solution-based nature of this company in a way that is distinctive within the category.

Creative Byline

Creative Byline

PO Box 1738 Holland MI 49422-1738
p 616.494.0431 f 616.494.0432
creativebyline.com

CLIENT: Creative Byline

STUDIO: People Design
CREATIVE DIRECTOR: Geoffrey Mark
DESIGN DIRECTOR: Brian Hauch
DESIGNERS: Marie-Claire Camp, Jason Murray,
Tim Calkins

CONCEPT: Creative Byline is an online resource
that connects writers and publishers. The identity
conveys "attraction" and "coming together" using
familiar tools — a magnet and paperclip.

Creative Byline

PO Box 1738 Holland MI 49422-1738
p 616.494.0431 c 616.403.1882 f 616.494.0432
brad.maclean@creativebyline.com
creativebyline.com

Creative Byline, LLC

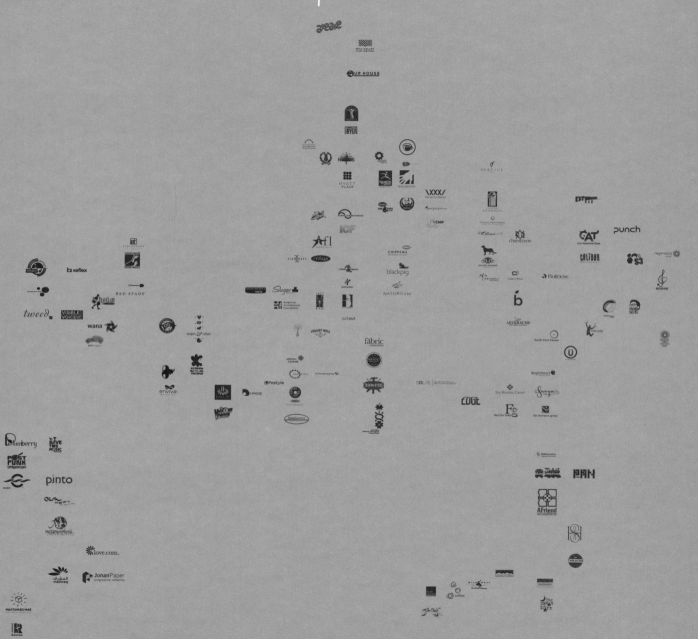

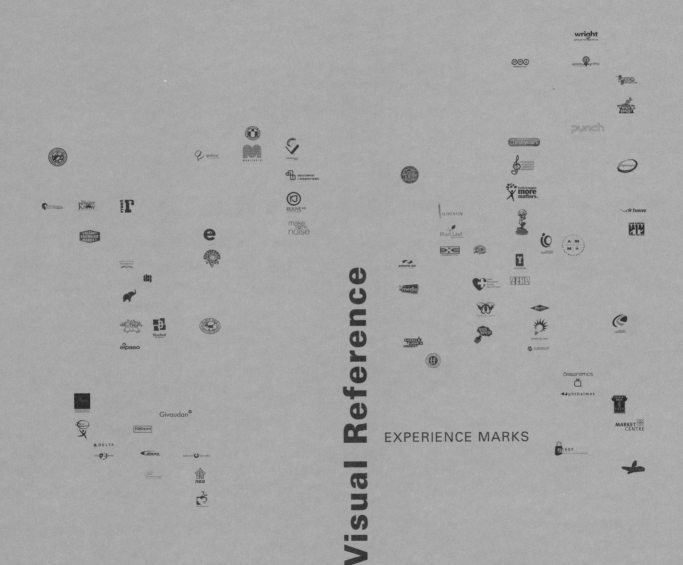

Visual Reference

EXPERIENCE MARKS

MILL VALLEY FILM FESTIVAL

KILT & BAGEL

CLIENT: California Film Institute
STUDIO: MINE™
ART DIRECTOR: Christopher Simmons
DESIGNERS: Christopher Simmons, Tim Belonax
CONCEPT: The new Mill Valley Film Festival logo is a stylized combination of the letterforms M and V. In the valley of the V rests a tiny heart, symbolizing the intersection of art and nature and the festival's love of film.

CLIENT: Rensselaer Polytechnic Institute (RPI)
STUDIO: Panarama Design
DESIGNER: Lauri Baram
CONCEPT: Client requested a contemporary graphic, sophisticated, but simple, to project an image of discovery, creativity and innovation. This event, *Design Your Future Day,* brings high school girls with an interest and aptitude in math and science to RPI for an exciting day of hands-on exploration in engineering, science, and technology.

CLIENT: 2004 Center County Pet Extravaganza
STUDIO: Sommese Design
ART DIRECTOR: Lanny Sommese
DESIGNER/ILLUSTRATOR: Lanny Sommese
CONCEPT: For this annual pet celebration, Sommese did not want the image to have the graphic feel of a logo. Considering the subject Sommese felt it should be softer and friendlier, so he did a playful pen & ink drawing of the cat perched on the dog's back and reversed the dog drawing to black to give it a dynamic positive/ negative appearance. The green type as grass was obvious.

CLIENT: Kilt & Bagel
STUDIO: Another Limited Rebellion (ALR)
DESIGNER: Noah Scalin
ILLUSTRATOR: Noah Scalin
CONCEPT: Kilt & Bagel is a small theater company in New York City. With such a funky name, showing it visually was a great way to engage viewers.

CLIENT: Bread & Tulips
STUDIO: Another Limited Rebellion (ALR)
DESIGNER: Noah Scalin
Illustrator: Noah Scalin
CONCEPT: Bread & Tulips is a children's birthday performer / clown in New York City. The goal was to give a sense of the playful fun personality of the performer while also showing that she was appropriate for sophisticated New York City parents.

CLIENT: iVillage
STUDIO: Alexander Isley, Inc.
CREATIVE DIRECTOR: Alexander Isley
MANAGING DIRECTOR: Aline Hilford
CONCEPT: A logo created for the online community with a clean, typographic approach that emphasizes the "i."

CLIENT: Stop AIDS/Ukraine

STUDIO: Sommese Design
DESIGNER: Lanny Sommese
DESIGNER: Lanny Sommese, Jason Dietrich, Ryan Russell

CONCEPT: The idea behind these logos is intended to be obvious and straightforward — to typographically demonstrate the word AIDS being halted, taken over, etc. by the word STOP.

CLIENT: Rockhal

STUDIO: Vidale-Gloesener
CREATIVE DIRECTOR: Silvano Vidale
DESIGNERS: Tom Gloesener, Nicole Goetz

CONCEPT: Logo and corporate design for a music hall in Luxembourg. The guitar pick was the perfect image to signify the spirit of the museum and frame its name.

CLIENT: Metamorphosis Mind + Body

STUDIO: Another Limited Rebellion (ALR)
DESIGNER: Noah Scalin

CONCEPT: Metamorphosis Mind + Body is a day spa in Richmond, Virginia. They wanted a logo to reflect their natural sensibilities and the refined tastes of their customers.

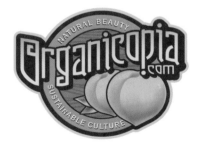

CLIENT: The Performance Initiative

STUDIO: Another Limited Rebellion (ALR)
DESIGNER: Noah Scalin

CONCEPT: Created for The Performance Initiative, this project encouraged young people to get involved in electoral politics. The modern, funky aesthetic was appropriate for the audience, which was mostly composed of urban college kids.

CLIENT: The Fairfax Library Foundation

STUDIO: Doug Fuller, Logo & Identity Designer
CREATIVE DIRECTOR/DESIGNER: Doug Fuller

CONCEPT: The Fairfax Library Foundation is a non-profit organization that raises funds to support the public libraries in Fairfax County, Virginia. The client requested that the new logo be "classic" and "swashy" and something that would look good on lapel pins. The resulting logo was designed to be seen as a book or a banner and the typeface and colors hint at Fairfax County's colonial history.

CLIENT: Organicopia

STUDIO: Another Limited Rebellion (ALR)
DESIGNER: Noah Scalin
ILLUSTRATOR: Noah Scalin

CONCEPT: The goal of this logo for Organicopia, a blog dedicated to healthy lifestyles and bodies, was to create an update of classic fruit crate labelling.

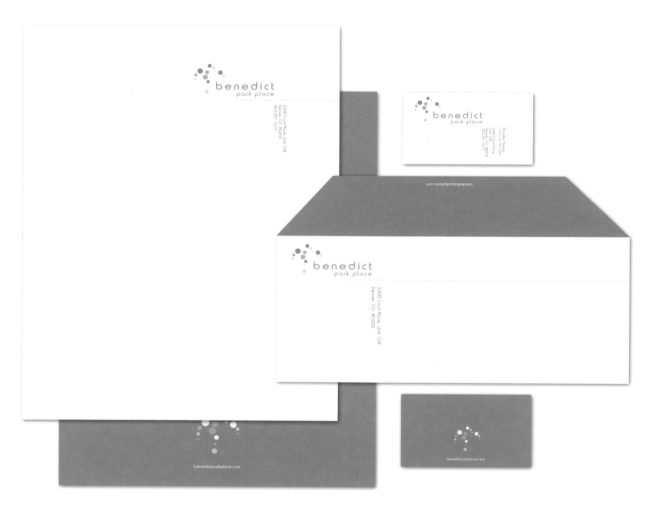

CLIENT: Benedict Park Place

STUDIO: Cranium Studio
PRINCIPAL / CREATIVE DIRECTOR: Alex Valderrama
DESIGNER: Andrew Zareck

CONCEPT: Because of the property's close proximity to an historical fountain, the logo conveys movement of water in a modern, crisp way through a configuration of dots in variable sizes and shades of blue. The typeface provides a feeling of community and approachability while the colors give the impression of a fresh, new development.

KÄLTÉITENG

Kayl, le 12 août 2006

Françoise Mustermann
12, rue de la Fontaine
L-1234 Tétange

Magna feugait autat. Ro er sustrud doloreros nonsed tat iureros dignim veliqui smoluptat. Ex er iriusciduis at nulluptat irilit nis nonseni smolore do exeraessecte modolor ercilis issequat, sisl dolorem essis esed dion henim del dolortion hendign iametum in utpat adio od tis adip eummodiam, suscili quisci ex esed magna conum nonse et wis dolor senim.

Madame Mustermann,

Magna feugait autat. Ro er sustrud doloreros nonsed tat iureros dignim veliqui smoluptat. Ex er iriusciduis at nulluptat irilit nis nonseni smolore do exeraessecte modolor ercilis issequat, sisl dolorem essis esed dion henim del dolortion hendign iametum in utpat adio od tis adip eummodiam, suscili quisci ex esed magna conum nonse et wis dolor senim.

Seniam acin er se min vel utpatissit loborerat. Duipissit, sustrud c lan utpat euis non hent alit al.

Boîte Postale 56 L-3601 Kayl

John Lorent
Bourgmestre

KÄLTÉITENG

Commune de Kayl-Tétange Boîte Postale 56 L-3602 Kayl Tél (+352) 56 00 66 1
Fax (+352) 56 33 23 Email commune@kayl.lu **www.kayl.lu**

KÄLTÉITENG

CLIENT: Community of Kayl-Tétange

STUDIO: Vidale-Gloesener
CREATIVE DIRECTOR: Silvano Vidale
DESIGNER: Tom Gloesener

CONCEPT: Identity system for Kayl-Tétange, Luxembourg — a clear, visual unification of a living community. The identity is based on the graphic elements of the letter K, an angle between several vertical lines, which makes this identity very dynamic. A color palette was specified to confer depth and a certain volume to the logo. Overall, the yellow tones and the clean lines of the typography add a pleasant and reassuring effect. The strength of this identity lies in its visual simplicity, which makes it very flexible for many applications.

CLIENT: Brian Olsen — Art in Action

STUDIO: BrandSavvy, Inc.
ART DIRECTOR: Karl Peters
DESIGNER: Karl Peters

CONCEPT: Art in Action is a performance artist who works with music, intensity, his hands and brushes. He paints a picture in his own style of well known people, while speaking about how creativity is in all of us. The logo is a depiction of his intensity as a showman.

CLIENT: Quince at the Homestead

STUDIO: Visual Voice
DESIGNER: Kayo Takasugi

CONCEPT: Quince at the Homestead specializes in contemporary American cuisine with a long tradition of high-end and fine dining. An organic, free-flowing form evokes both the letter Q and the quince, a small yellowish fruit. The color scheme is strong yet welcoming. Belwe, the typeface used for the logotype, combines the quirky, decorative features of Art Nouveau with the more rational lines of a modern slab-serif typeface.

CLIENT: Koch Industries, Inc.

STUDIO: Koch Creative Group
ART DIRECTOR: Dustin Commer

CONCEPT: This logo signifies is a company-wide event celebrating the founders day with fireworks and picnic.

CLIENT: Koch Industries, Inc.

STUDIO: Koch Creative Group
ART DIRECTOR: Dustin Commer

CONCEPT: The KII company-wide picnic was held at the local ball diamond. This event included bingo, Texas hold'em and a BBQ.

CLIENT: INVISTA — Bruce Rowley

STUDIO: Koch Creative Group
ART DIRECTOR: Dustin Commer
ACCOUNT EXECUTIVE: Tarcy Chen
LEADER: Terri McCool

CONCEPT: The INVISTA Apparel Summit is an annual 3-day meeting of managers in Wichita, Kansas. The conference features clothing lines and fabrics provided to manufactures. The hanger icon adds appeal and interest to the annual conference.

CLIENT: University Park United Methodist Church

STUDIO: Jeff Fisher LogoMotives
DESIGNER: Jeff Fisher

CONCEPT: Logo for North Portland Pride BBQ Festival. The image was used as the identifying logo and poster for this gay/lesbian community event sponsored by the University Park United Methodist Church. Traditional picnic images were used to create a celebratory design.

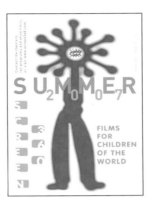

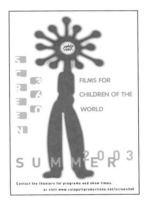

FILMS FOR CHILDREN OF THE WORLD

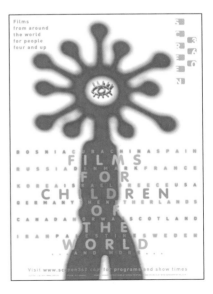

CLIENT: Katy Kavanaugh, Catapultproductions.net

STUDIO: Studio A N D
CREATIVE CONSULTANT : David Peters
ART DIRECTOR: Jean-Benoit Levy
DESIGNER: Jean-Benoit Levy

CONCEPT: Screen 360: "Films for Children of the World" is the project of a San Francisco native. Her vision is to create a film festival for an audience of young people in order to open their eyes to the "other" world. The logotype is composed of a film strip which the name of the festival appears.

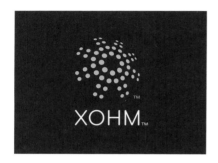

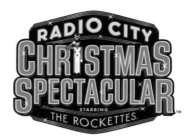

CLIENT: Xohm — A Sprint Nextel business unit
STUDIO: Lippincott
CREATIVE DIRECTOR: Rodney Abbot
DESIGNERS: Rodney Abbot, Peter Chun, Brendán Murphy

CONCEPT: Xohm is a new nationwide WiMAX wireless broadband network from Sprint Nextel. With Xohm, users will experience a new level of mobile internet freedom, downloading movies, watching video, playing games, etc., on any WiMAX enabled device at speeds normally found only with fixed line access such as DSL or Cable, and without the constraints of contracts and cancellation fees that come with other wireless services. The new identity captures the sense of connecting people, places and devices, combining a feeling of both attraction and radiance.

CLIENT: Radio City
STUDIO: Sterling Brands
DESIGNERS: Stephen Dunphy, Marcus Hewitt, Marc Sampogna

CONCEPT: Sterling Brands updated this logo for Radio City Christmas Spectacular, cablevision, with a warm, festive and entertaining design to work across print, television and interactive media.

CLIENT: The Shawncast
STUDIO: Fifth Letter
DESIGNER: Elliot Strunk
ILLUSTRATOR: Elliot Strunk

CONCEPT: Logo for a podcast covering politics and entertainment. The mark combines two familiar icons: the American Flag and a film director's clapboard in a hand-rendered form to capture the immediacy and day-to-day changes in American politics and entertainment.

CLIENT: Center for Design Innovation
STUDIO: Fifth Letter
DESIGNER: Elliot Strunk
ILLUSTRATOR: Elliot Strunk

CONCEPT: The Digital Arts Symposium is a regional gathering of design professionals. The multi-colored graphic marks in a spiral configuration convey the diverse cycles of topics of this symposium

CLIENT: HP Hood, LLC — Making Strides Against Breast Cancer
STUDIO: Arsenal Design, Inc.
DESIGNER: Mark Raebel

CONCEPT: This mark was created to sponsor participation in the Boston Making Strides event. A collage of iconic imagery set the context of this event.

CLIENT: Atlas Health Club
STUDIO: Arsenal Design, Inc.
DESIGNER: Mark Raebel

CONCEPT: Fashioned after the Atlante dalla Collezione Farnese, this iconic interpretation of the original sculpture is a symbol of strength and integrity.

CLIENT: Castiglion del Bosco by Ferragamo

STUDIO: Sterling Brands
DESIGNERS: Janice Pedly (logo), Kim Berlin and Domenica Davi (collateral)

CONCEPT: The objective was to develop a sophisticated and artisan look for one of the world's most unique and exclusive club properties. Only the finest materials were used to reflect the premium nature of the brand.

CLIENT: Post Punk Kitchen
STUDIO: Another Limited Rebellion (ALR)
DESIGNER: Noah Scalin
CONCEPT: Designed for use on a popular website and public access program devoted to vegetarian cooking and punk rock music. Handmade typography and illustration represent the DIY aesthetic of the creators and fans.

CLIENT: Calgary Farmers' Market
STUDIO: WAX
DESIGN DIRECTOR: Monique Gamache
DESIGNER: Scott Shymko
CONCEPT: The Calgary Farmers' Market is home to over 80 vendors with an emphasis on providing access to high quality, locally-produced food. The Farmers' Market's logo was created to suggest a sense of history and authenticity especially as it applies to agriculture.

CLIENT: Zynap
DESIGNER: Steve Gibson
CONCEPT: There are not many brands brave enough to go with a name that begins with 'z' but Zynap is run by a very feisty entrepreneur. Zynap's core product is human resources software — a powerful enterprise-wide package that allows senior management to assess staff in a simple way. Zynap's application made the workforce truly transparent for the user. The visualization of that idea is simple: the Z is able to pinpoint what you need to know, when you need it, and gives a clear view of all the relevant information.

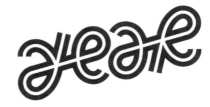

CLIENT: American Museum of the Moving Image
STUDIO: Alexander Isley, Inc.
DESIGNER/CREATIVE DIRECTOR: Alexander Isley
CONCEPT: This logo refers to a viewfinder and a real "eye" as a way to provide a rebus for an organization with a long name.

CLIENT: Target Margin Theater
STUDIO: Another Limited Rebellion (ALR)
DESIGNER: Noah Scalin
ILLUSTRATION: David Zinn
CONCEPT: Target Margin is a small Downtown theater company in New York City. This series of logos represents the diverse range of their work, which blends modern sensibilities with classic texts. The logos can be used interchangeably and were illustrated by their costume designer.

CLIENT: SchyerSF
STUDIO: MINE™
ART DIRECTOR: Christopher Simmons
DESIGNERS: Christopher Simmons, Tim Belonax
CONCEPT: YEAR is a nightlife brand that celebrates fifty years of rock and roll (1956–2006). Records are spun and bands perform covers, all from one particular year. The mark is a rhythmic, grooved ambigram that can be spun around and around (like a record, baby) and always read correctly.

CLIENT: Design 21

STUDIO: CullenArt
ART DIRECTOR: Leigh Cullen
DESIGNER: Leigh Cullen
ILLUSTRATION: Leigh Cullen

CONCEPT: *Selfless* integrated marketing campaign. Design 21 posted a global call for entries for a public awareness campaign focused on reducing global warming. Cullen submitted an integrated marketing campaign including an identity, copy, sponsorship ideas, and cross-media applications for the brand. The identity emphasizes each person's ability to reduce his/her carbon dioxide emissions with simple, "selfless" actions, like carpooling or using reusable grocery bags.

CLIENT: The Public Address Network
STUDIO: Another Limited Rebellion (ALR)
DESIGNER: Noah Scalin
ILLUSTRATOR: Noah Scalin

CONCEPT: The PAN is an Internet video program which pulls together diverse artists to present alternative media for small screens. The logo gives a nod to the technology used while also functioning as a tangram which could be easily reconfigured and used in a variety of ways in video promotions.

CLIENT: Ahimsa Yoga
STUDIO: Blu Art & Design
DESIGNER: Triesta Hall

CONCEPT: In the creation of this logo, it was important to research the Yoga philosophy of Ahimsa, meaning "non-harming." Therefore the logo is a graphic representation of the heart chakra.

CLIENT: Green Girl Guide
STUDIO: Hughes design | communications
DESIGNER: Courtney Owens Zieliski, Partner

CONCEPT: Greengirlguide.com is an online magazine featuring the latest in green fashion, beauty and lifestyle. This logo was developed to convey an easy, feminine, stylish sensibility, with a mindfulness of green issues. The pink bird is the GGG mascot.

CLIENT: Foglifters
STUDIO: Mazziotti Design
DESIGNER: Jordon Mazziotti

CONCEPT: Foglifters is a social networking web site. The concept of this logo is based on the motivation to get out of your comfort zone. This is signified by the type pushing out of the clouds (fog).

CLIENT: Ask Who Do You Know?
STUDIO: Mazziotti Design
DESIGNER: Jordon Mazziotti

CONCEPT: A social networking web site for businesses. The web site name is bound into speaking balloons to emphasize collaboration and exchange of ideas.

CLIENT: Midtown Ventura
DESIGNER: Gunnar Swanson

CONCEPT: The Midtown Ventura logo represents the Midtown Ventura Community Council, a neighborhood organization, but also the neighborhood in general. The typeface evokes the late 1920s — the era when much of Midtown Ventura was built — and the image depicts its position between the ocean and the coastal hills.

al markhia
gallery

CLIENT: Al Markhia Gallery

STUDIO: Halim Choueiry
DESIGNER: Halim Choueiry and Aida Hashim

CONCEPT: The splashing, colorful ying buttery represents the gallery for its travelling, inspiring, and collecting qualities. The left half of the butterfly is shape of Al Markhia map, a neighborhood in Doha, Qatar.

Abdulla bin Ali
bin Soud al Thani
director

al markhia
gallery

m 00974 548 2914
o 00974 442 2550
f 00974 442 2552
p 1822 Doha Qatar
e cefdoha@qatar.net.qa

www.myqatar.org

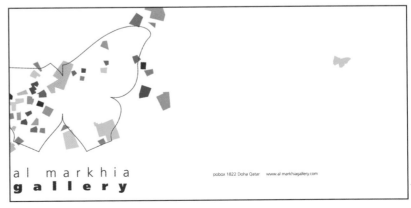

al markhia
gallery

pobox 1822 Doha Qatar www.al markhiagallery.com

CLIENT: Home & Hospice Care of Rhode Island, Hospice Walk 2005

STUDIO: Arsenal Design, Inc.
DESIGNER: Mark Raebel

CONCEPT: The focus of this mark relies on the critical component of this event — its participants and their motivation.

CLIENT: Virginia Chamber of Commerce

STUDIO: Trim — Clarified Visual Communication
DESIGNER: Leo Caldas

CONCEPT: The excitement, color, and richness of the Latin way of life comes together through music, food, arts and crafts at this annual celebration. The objective was to capture the festive element through an authentic Hispanic presentation. The surface of the mark serves as a universal symbol, surrounded by accent marks that collaborate with the title of the event, keeping the integrity of the language intact.

CLIENT: Pregatta Party 2005

STUDIO: Arsenal Design, Inc.
DESIGNER: Mark Raebel

CONCEPT: Used on the invitation for the party the night before the big Regatta... thus, PREgatta.

SPARTANBURG
CREATIVE ENERGY

CLIENT: Quantum Sails

STUDIO: Arsenal Design, Inc.
DESIGNER: Mark Raebel

CONCEPT: With the company's logo used in a central location, this campaign logo was used to inspire those who know.

CLIENT: Ranapo Country Day Camp

STUDIO: Arsenal Design, Inc.
DESIGNER: Mark Raebel

CONCEPT: Inspired by the youth market, three dimensional treatments and halftone patterns add to the playfulness of this kids' organization.

CLIENT: City of Spartanburg, South Carolin

STUDIO: Zoo Valdes
DESIGNER: Marius Valdes

CONCEPT: The city of Spartanburg asked for a a short-term logo that could be used in a 2 year marketing campaign to promote the growing city as a home for creative individuals. The City asked that the logo also reflect the feeling of an energetic, family-friendly community. This logo was also designed with the idea that the organic shapes could be easily adaptable and inter-changeable to create a comprehensive yet flexible application to a variety of media.

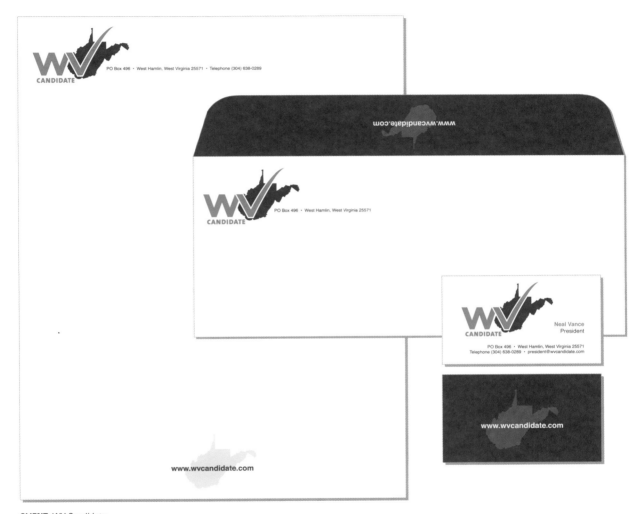

CLIENT: WV Candidate

STUDIO: Mazziotti Design
DESIGNER: Mazziotti Design

CONCEPT: Logo for a political website based in West Virginia, that provides information on the upcoming elections.

CLIENT: XTRI

STUDIO: Arsenal Design, Inc.
DESIGNER: Mark Raebel

CONCEPT: A web site that offers all the latest race results for international triathlon events. The three dots are representative of the three sport segments: swimming, biking, running.

CLIENT: Cornelia de Lange Syndrome (CdLS) Foundation

STUDIO: Designlore
DESIGNER: Laurie Churchman

CONCEPT: This logo was developed for a year-long celebration of the Foundation's beginning. It was applied to promotional pieces, the website, annual conference materials and contribution packages. The colors of the Foundation's corporate colors, and variations of a heart symbol are the primary signifiers.

CLIENT: Holland + Knight Charitable Foundations, Inc.

STUDIO: Jeff Fisher LogoMotives
DESIGNER: Jeff Fisher

CONCEPT: *Young Native Writers Essay Contest* is a nationwide essay contest for Native American high school students, sponsored by the Holland+Knight Charitable Foundation. It represented by this logo featuring an eagle feather as a writing instrument. The input of tribal leaders was sought in the process of creating the image

CLIENT: New Kensington Community Development Corporation

UNIVERISTY: Tyler School of Art / Temple University
PROFESSOR: Stephanie Knopp
DESIGNER: Alan Cho

BRIEF: An identity project for monthly performances at a neighborhood community center. The image of a streetlight with notes emanating from its lighted head signify music at night. In this case, jazz.

CLIENT: Haringey Sixth Form Centre

STUDIO: The Black Pig
DESIGNER: The Black Pig

CONCEPT: UK-based Haringey Sixth Form Centre is a totally inclusive learning environment committed to enabling all young people to achieve their full potential. The configuration of framed, soft-cornered squares in various colors signifies the richness of the school's curriculum and diversity of its students and community.

CLIENT: Area 251

ART DIRECTOR: Ryan Russell
DESIGNER: Ryan Russell

CONCEPT: Area 251 is a unique and secluded outdoor motocross facility that caters to intermediate and advanced riders. This mark was designed to highlight the hidden and secluded atmosphere of this popular location, in the same spirit as the notorious Area 51 in Nevada.

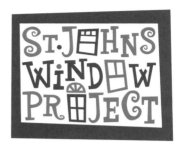

CLIENT: Lawrence School Lions

STUDIO: Little Jacket
DESIGNER: Michael Burton

CONCEPT: Logo for a Cleveland, Ohio high school sports program. This mark captures the features of the lion with visual characteristics that depart from traditional sports mascot logos to represent the spirit of this high school: youth, vitality, seriousness, dedication...and fun.

CLIENT: The Educational Trip Company, Ltd.

STUDIO: The Black Pig
DESIGNER: The Black Pig

CONCEPT: *Inspiration for Life* is a conference series developed specifically for Gifted and Talented students in England. These exciting and inspiring one day events, held regionally, bring together students and business organisations, are designed to provide high potential young people with the inspiration and motivation to maximise and use their abilities successfully in the wider world. A simple, typographic solution with a star framing the "i" conveys this spirit.

CLIENT: St. Johns Window Project

STUDIO: Jeff Fisher LogoMotives
DESIGNER: Jeff Fisher

CONCEPT: St. Johns Window Project is an annual art event in Portland during which the work of local artists is displayed for a month in the storefront windows of businesses in the St. Johns community. The window graphic forms seemed like natural replacements for the "o" letterforms in the event name.

CLIENT: Orlando Latin-American Film & Heritage Festival

STUDIO: Blu Art & Design
DESIGNER: Triesta Hall

CONCEPT: This annual festival is a celebration of many diverse Latin cultures, and needed to be universal in its representation. the designer focused on the sun and ocean, two elements that drive everything from their dance to art within their respective cultures.

CLIENT: America Online (AOL)

STUDIO: Sterling Brands
DESIGNER: Kim Berlin, Marcus Hewitt, Satoru Wakeshima

CONCEPT: The objective was to launch a new online dating service for AOL, within an already saturated market. The identity needed to appeal to women, while not alienating men, and communicate the casual, fun, sassy and flirtatious personality of the love.com community.

CLIENT: Unicef / Artwagen™

STUDIO: Sterling Brands
DESIGNER: Marcus Hewitt

CONCEPT: In many cities around the world, Volkswagen Beetle cars were transformed into rolling works of art. All exhibits benefited Unicef, in a tribute to the legendary creators of our time.

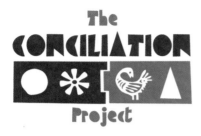

CLIENT: The Conciliation Project (TCP)

STUDIO: Thinkhaus
ART DIRECTOR: Matthew Strange
DESIGNER: John O'Neill

CONCEPT: The Conciliation Project (TCP), is a non-profit social justice organization that conducts theater performances concerning the harmful effects of racism. Thinkhaus designed the TCP logo to portray the four parts of their mission: Community, Creativity, History, and Transformation. The TCP mission promotes an open dialogue about racism in America to repair its damaging legacy. Each part of the mission is illustrated using an African symbol placed in a bar with a gap between them, symbolizing how racism divides people and cultures. The African symbols were used to show that the organization gains its creative inspiration from African culture and art. The typeface FF Cutout was used in the design of the logo to convey the hand-crafted sculpture qualities of African art.

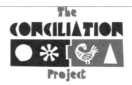

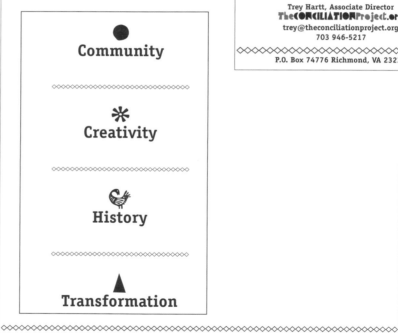

History Live: The Exhibit

The Conciliation Project in Collaboration With Gallery 5

Free Event: March 7, 2008, 7PM–9PM

Design: Thinkhausdesign.com

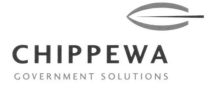

CLIENT: triangle productions!

STUDIO: Jeff Fisher LogoMotives
DESIGNER: Jeff Fisher

CONCEPT: Stylized images of the traditional drama and comedy masks make an appearance in this anniversary logo for the 14th anniversary of a local theatre company.

CLIENT: Art Directors Club of Metropolitan Washington (ADCMW)

STUDIO: Doug Fuller, Logo & Identity Designer
CREATIVE DIRECTOR/DESIGNER: Doug Fuller

CONCEPT: After almost 30 years with the same logo, the ADCMW identity needed some refreshing. The flexible color palette uses six dark and light colors for the bottom and top portions, allowing for multiple color combinations and a dynamic, but consistent look. The new logo gives the organization a strong, flexible mark that can be used in various media and in a variety of ways.

CLIENT: Chippewa Government Solutions

STUDIO: Doug Fuller, Logo & Identity Designer
CREATIVE DIRECTOR/DESIGNER: Doug Fuller

CONCEPT: Chippewa is a service-disabled, veteran, and Native-American-owned small business acting as a subcontractor to larger companies doing business with the Federal Government. The challenge was to portray the Chippewa name without resorting to clichéd Native-American imagery (no rough or hand-drawn type). The clean, modern logo works well in the government sector while reflecting the Chippewa tribe's origins by depicting an leaf or arrow and also the letter C.

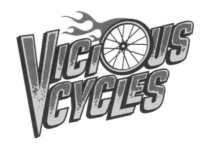

CLIENT: The Field Museum of Natural History

STUDIO: Crosby Associates
CREATIVE DIRECTOR/DESIGNER: Bart Crosby

CONCEPT: A simple hand-drawn circle with four arrows pointing from its center to is edge at once signifies the earth and compass points. The hand-drawn characteristic conveys note-making while exploring in the field.

CLIENT: Vicious Cycles

STUDIO: Another Limited Rebellion (ALR)
DESIGNER: Noah Scalin
ILLUSTRATOR: Noah Scalin

CONCEPT: This logo for *Vicious Cycles,* an indie film about rival bicycle gangs, was inspired by classic B-movie poster art.

CLIENT: WMMC Griffin Internet Radio

STUDIO: Mazziotti Design
DESIGNER: Jordon Mazziotti

CONCEPT: A logo for a Internet radio system headquartered at Marymount Manhattan College in New York.

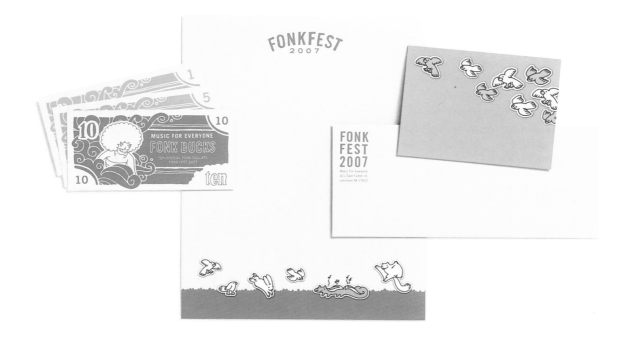

CLIENT: Fonk Fest 2007

STUDIO: Go Welsh
ART DIRECTOR: Craig Welsh
DESIGNERS: Nichelle Narcisi

CONCEPT: Stationery for Fonk Fest, a two-day music festival sponsored by Music For Everyone to raise money to fund music education programs.

MANCHESTER
STATION

CLIENT: Manchester Station
STUDIO: WAX
CREATIVE DIRECTOR: Monique Gamache
DESIGNER: Jonathan Herman

CONCEPT: Manchester Station is a 13-story condominium development located in an up-and-coming-neighbourhood in Calgary.

CLIENT: Doug Fuller, Logo & Identity Designer
STUDIO: Doug Fuller, Logo & Identity Designer
CREATIVE DIRECTOR/DESIGNER: Doug Fuller

CONCEPT: After at least a year working as a freelance logo and identity designer with no one asking to see his own identity, Fuller finally created one for himself. Since most of his clients refer him by saying "You have to have Doug design your logo," he felt a simple, iconic representation of his name would best reflect his straightforward approach to logo design.

CLIENT: triangle productions!
STUDIO: Jeff Fisher LogoMotives
DESIGNER: Jeff Fisher

CONCEPT: In creating this logo for a theatrical production, *The Dream State,* Fisher imagined someone lying in bed and seeing the show's name on the ceiling, with some letterforms being replaced by stars.

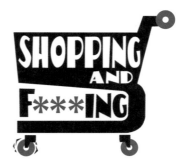

CLIENT: AIDS Response Seacoast
STUDIO: Jeff Fisher LogoMotives
DESIGNER: Jeff Fisher

CONCEPT: This logo is used to identify an annual AIDS fundraising walk. In the image, the footprints in the sand, soon to be washed away by waves, represent those lost over the years to the disease.

CLIENT: The Tipperary Inn
STUDIO: Arsenal Design, Inc.
DESIGNER: Mark Rabel

CONCEPT: A logo for the 2005 St. Pat's event at Dallas' premiere Irish Pub.

CLIENT: triangle productions!
STUDIO: Jeff Fisher LogoMotives
DESIGNER: Jeff Fisher

CONCEPT: This is the identity for the triangle productions! theatrical presentation *Shopping and F***ing*, complete with wobbly front wheel on the shopping cart.

WIND ROSE

CLIENT: Wind Rose

STUDIO: Spin Creative Group
CREATIVE DIRECTOR: Brigette Schabdach
DESIGNER: Leslie Bell
ILLUSTRATOR: Weber Design, Inc.

CONCEPT: Wind Rose is a company that owns multiple private properties in the North and South Americas. Before the compass rose (the compass itself only became known to the west during the 13th century), maps included what was called a wind rose to help orient the reader. Because of the multiple properties in multiple locations, this name brought all together under one name.
DETAILS: Printed on Cranes with the logo as a sculpted die. Four color plus 2 PMS printing.

CLIENT: Social Savant

STUDIO: Mazziotti Design
DESIGNER: Jordon Mazziotti

CONCEPT: A social networking web site for busy businessmen. The mark is rendered in a manner reminiscent of 1920s Art Nouveau, with a typeface that places it in the context of the electronic culture of the new millennium.

CLIENT: Society of Women Engineers 2003 National Convention

STUDIO: Robert W. Taylor Design, Inc.
ART DIRECTOR: Robert W. Taylor
DESIGNER: Robert W. Taylor, Dominique Etcheverry

CONCEPT: The theme for this convention was "Supporting the World Through Engineering." Taylor's solution was to find a fresh, contemporary way to illustrate this theme. The execution of the rough idea using color and gradations brought a simple idea to life.

CLIENT: Holland + Knight Charitable Foundation, Inc.

STUDIO: Jeff Fisher LogoMotives
DESIGNER: Jeff Fisher

CONCEPT: This logo for Holocaust Remembrance Project gives a graphic identity to the annual Holocaust remembrance essay contest for high school students. The triangle elements are used in a positive manner to take ownership of the negative image of the concentration camp uniform identification patches from the past. Each color represents a different classification of prisoners in the camps.

CLIENT: HP Hood, LLC – Sox Tops for Kids

STUDIO: Arsenal Design, Inc.
DESIGNER: Mark Raebel

CONCEPT: This logo utilizes the original trade mark of the Boston Red Sox for a charitable program created by these two organizations.

CLIENT: Roger King Fine Art

STUDIO: Arsenal Design, Inc.
DESIGNER: Mark Raebel

CONCEPT: This graphic was created for an art exhibit showcasing two master artists' collections. The typography is reflective of their active period: the 1880s.

CLIENT: Lockland Park Neighborhood Association

STUDIO: Fifth Letter
DESIGNER: Elliot Strunk

CONCEPT: Logo for Lockland Park neighborhood which has a city park as a central gathering place for residents.

32 *Winds*

CLIENT: 32 Winds, The Collection of Wind Rose Properties

STUDIO: Spin Creative Group
CREATIVE DIRECTOR: Brigette Schabdach
DESIGNER: Leslie Bell
WRITER: Sandy Rowe

CONCEPT: The compass rose has appeared on charts and maps since the 1300's when the portolan charts first made their appearance. The term "rose" comes from the figure's compass points resembling the petals of the well-known flower. Originally, this device was used to indicate the directions of the winds (and it was then known as a wind rose), but the 32 points of the compass rose come from the directions of the eight major winds, the eight half-winds and the sixteen quarter-winds. These points represent The Collection of Wind Rose Properties.

DETAILS: Printed on Gruppo Cordenons, VIP, Canaletto, Grana Grossa Bianco. Letterhead and envelopes on 85# text, business cards on 111# cover. Four color printing plus letterpressing.

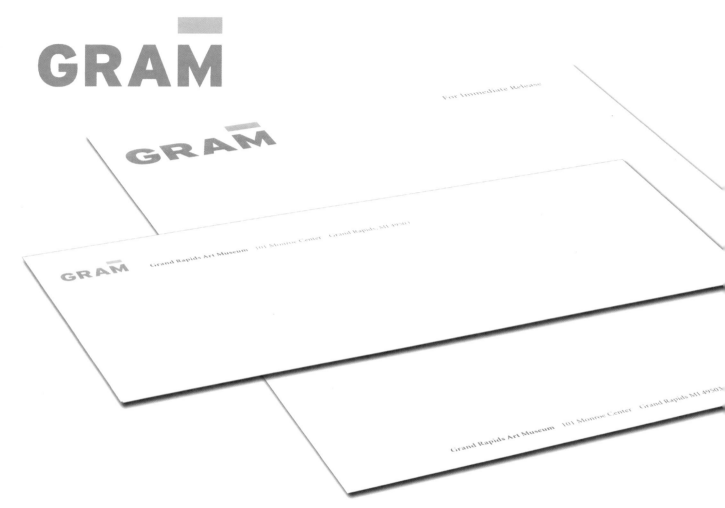

CLIENT: Grand Rapids Art Museum (GRAM)

STUDIO: People Design
CREATIVE DIRECTOR: Yang Kim
DIRECTOR OF GRAPHIC DESIGN: Sahron Oleniczak
DESIGN DIRECTOR: Brian Hauch
DESIGNERS: Jason Murray, Adam Rice

CONCEPT: The Grand Rapids Art Museum contracted architect Kulapat Yantrasast to design and build the world's first LEED certified art museum. The new building that features three large "lanterns" — retangular lights on the roof.

The logo reflects the aesthetics of the building and the philosophy of the museum. Modern, stately, confident. The bar over the M looks like one of the lanterns on the building in elevation.

CLIENT: Downtown Middle School

STUDIO: Fifth Letter
DESIGNER: Elliot Strunk
ILLUSTRATOR: Elliot Strunk

CONCEPT: Logo for urban middle school embracing learning, physical activity and the arts.

CLIENT: Renaissance Theatre Company

STUDIO: Fifth Letter
DESIGNER: Elliot Strunk

CONCEPT: Logo for start-up regional theatre group. The mark focuses on the typographic treatment of the company name, set in a formal medallion shape.

CLIENT: Benicia Historical Museum

STUDIO: Jeff Fisher LogoMotives
DESIGNER: Jeff Fisher

CONCEPT: The Benicia Historical Museum at the Camel Barns had a split personality of multiple identifying images prior to this re-design. The Civil War-era U.S. Army base needed a logo representative of the time period and its history. The camel image from an antique etching of the museum was used in the design.

CLIENT: George Fox University

STUDIO: Jeff Fisher LogoMotives
DESIGNER: Jeff Fisher

CONCEPT: The Tilikum identity is a re-design of an existing image representing the retreat center for George Fox University. The wilderness location and serenity of the center are graphically conveyed in the logo.

CLIENT: USDA Forest Service

STUDIO: Jeff Fisher LogoMotives
DESIGNER: Jeff Fisher

CONCEPT: Fisher's own travels in New Mexico provided the inspiration for this logo for the USDA Forest Service's Valles Caldera National Preserve. The Federal lands are made up of an 89,000 acre ranch nested in a volcanic caldera.

CLIENT: MTV2's Mother Trucker Brand Mark

STUDIO: Little Jacket
DESIGNER: Michael Burton

CONCEPT: Proposed Brand Mark for MTV2 Mother Trucking Summer.

FRENCH LEAVE

CLIENT: Lauth Development
STUDIO: Sommese Design
ART DIRECTOR: Lanny Sommese, Kristen Sommese
DESIGNERS: Lanny Sommese, Kristen Sommese, Ryan Russell

CONCEPT: Sommese felt the butterfly was the perfect metaphor for the unspoiled natural setting that is Eleuthera, Bahamas. Adding silhouetted faces to the butterfly's wings was their way of visualizing the relationship between French Leave Resort and its pristine surroundings. In order to enhance the stylish, clean, and exclusivity of the resort, the logo was silver foil stamped and embossed in most of its applications.

Savannah Hill

CLIENT: Lauth Development
STUDIO: Sommese Design
ART DIRECTORS: Kristin Sommese, Lanny Sommese
DESIGNERS: Kristin Sommese, Lanny Sommese, Ryan Russell

CONCEPT: Savannah Hill is a high-end time-share community under development on the island of Eleuthra in the Bahamas. The client was looking for something that was stylish, upbeat and clean while, at the same time, capturing the spirit of the island, which has a history of colonial settlements, colorful antique homes and plantations and churches.

PORT CANAVERAL

CLIENT: Canaveral Port Authority
STUDIO: Sterling Brands
DESIGNERS: Kim Berlin, Marcus Hewitt, Barbara Scarpa

CONCEPT: The objective was to develop a new look to reflect Florida's hassle-free outlet to the sea's versatile cruise and cargo capabilities. The identity is a truly transporting, all-encompassing system.

CLIENT: Lewis & Clark State Historic Site
STUDIO: Plum Studio
DESIGNER: Heather Corcoran

CONCEPT: The objective was to create a logo to represent the Lewis & Clark State Historic Site. The solution combines map symbolism and a compass/surveyor marker to focus on the site at confluence of Missouri and Mississippi Rivers —the beginning of the famous journey of Lewis & Clark.

CLIENT: 836 Oak
STUDIO: Fifth Letter
DESIGNER: Elliot Strunk
ILLUSTRATOR: Elliot Strunk

CONCEPT: Logo for a downtown loft development company specializing in converting warehouse space. A combination of a typographic treatment of the name and an abstracted elevation rendering of a warehouse structure convey the essence of loft living spaces.

CLIENT: Friends of Vista House, Oregon State Parks Trust
STUDIO: Jeff Fisher LogoMotives
DESIGNER: Jeff Fisher

CONCEPT: The logo identifies the Vista House, which was built in 1916–1918 as a memorial to Oregon pioneers and is listed on the National Register of Historic Places. Today it as an interpretive center museum and viewpoint for travellers in the Columbia River gorge.

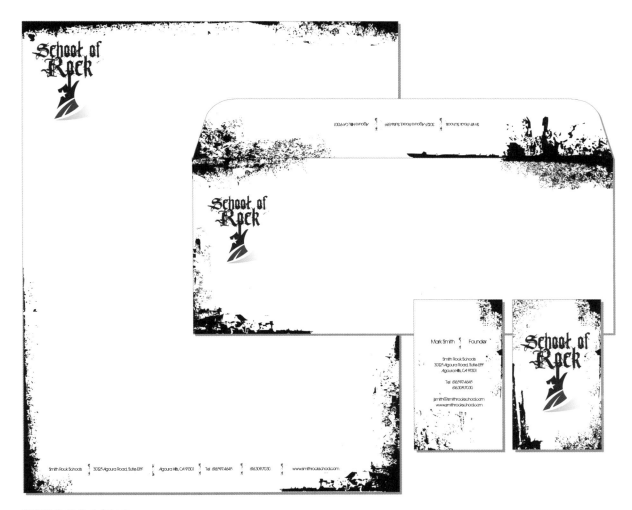

CLIENT: Smith Rock Schools

STUDIO: Mazziotti Design
DESIGNER: Jordon Mazziotti

CONCEPT: Smith Rock Schools (School of Rock). Gritty and edgy design to match the rock star image.